IMAGES
of America

THE OKLAHOMA
COWBOY BAND

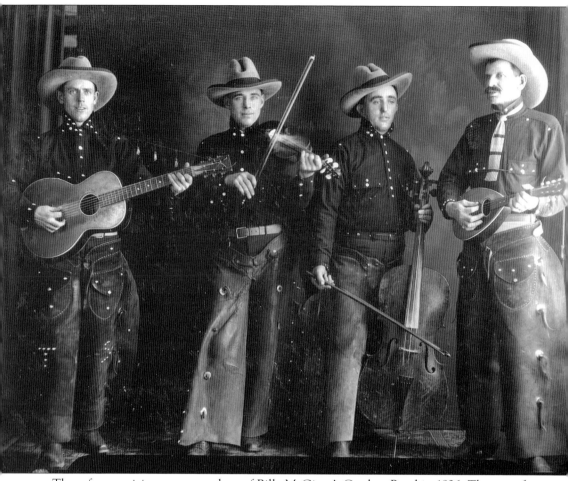

These four musicians were members of Billy McGinty's Cowboy Band in 1926. They are, from left to right, Nealy Huff, Johnny Bennett, unidentified, and Dave Cutrell. They were recruited for the band from the Ripley area, but after the band began traveling the vaudeville circuits in the East, family commitments led them to leave the band.

On the cover: This photograph is of the nation's first western band to achieve commercial success across the country. The band first played in 1925 as Billy McGinty's Cowboy Band, but in 1928, the name of the band was changed to Otto Gray and His Oklahoma Cowboys. This photograph is from around that time. Shown are, from left to right, band members Rube Tronson, unidentified, Claude "Doc" Purvis, Owen Gray, Florence "Mommie" Gray, and Otto Gray. The band was often called the Oklahoma Cowboy Band, and many people today remember it by that name. (Courtesy Washington Irving Trail and Museum.)

IMAGES
of America

THE OKLAHOMA COWBOY BAND

Carla Chlouber

ARCADIA
PUBLISHING

Copyright © 2008 by Carla Chlouber
ISBN 978-0-7385-5245-3

Published by Arcadia Publishing
Charleston SC, Chicago IL, Portsmouth NH, San Francisco CA

Printed in the United States of America

Library of Congress Catalog Card Number: 2008920749

For all general information contact Arcadia Publishing at:
Telephone 843-853-2070
Fax 843-853-0044
E-mail sales@arcadiapublishing.com
For customer service and orders:
Toll-Free 1-888-313-2665

Visit us on the Internet at www.arcadiapublishing.com

CONTENTS

ACKNOWLEDGMENTS

I have had the privilege of working with the Washington Irving Trail and Museum, southeast of Stillwater, Oklahoma, since it was founded in 1994. I thank my husband, Dale, who is the curator of the museum, for his determination in developing the museum and bringing the history of this wonderful part of the world to the public's attention. Unless otherwise noted, the photographs in this book are from the collections of the Washington Irving Trail and Museum.

This book would not have been possible without the generosity of the family of Otto Gray's second wife, Elsie. Her daughter, Mildred Clarkson, and her family generously donated photographs and other materials related to the Oklahoma Cowboy Band to the museum. Vicki George, a daughter of Mildred, has kindly allowed us to use her photographs—and memories—of Otto. Others who contributed to our knowledge of this historic western band are Kelly Powell, Loren Gray, and Glenn Shirley.

I am especially thankful to O. W. "Jack" McGinty (who died in 2001), his wife, Rose, and daughter Mary Ruth Koutz for their help in preserving the stories of the remarkable life of Billy McGinty—cowboy, Rough Rider, Wild West showman, champion broncobuster, and leader of the first cowboy band on radio. Billy and Otto are truly among "the best of the old West."

I am also grateful to Reba Bennett Harvey, who provided very helpful information about her father, Johnny Bennett, who was a member of Billy McGinty's Cowboy Band. My gratitude also goes to R. N. Purvis for sharing with us the story of the Oklahoma Indian Band, an offshoot of the Oklahoma Cowboy Band led by his father, Claude "Doc" Purvis.

Music historian Dr. John Wilson provided information about vaudeville in the early days of Oklahoma, and I am grateful for his help. I also appreciate suggestions offered by historian Dr. James Showalter. Of course, many others have helped to preserve the memory of the Oklahoma Cowboy Band, and I appreciate all they have done.

INTRODUCTION

Payne County, in north-central Oklahoma, has a rich and varied history. Traces of that history can be found in the ancient forests of the Cross Timbers, where post oaks, blackjacks, hickory, and elm are interspersed with open prairies. Native Americans lived and hunted in the area for centuries, long before the coming of the Europeans and the creation of Indian Territory.

The Louisiana Purchase, in 1803, included the land that is now Oklahoma. In 1832, America's first internationally acclaimed writer, Washington Irving, was part of an official United States expedition through eastern and central Indian Territory. He traveled with Indian Commissioner Henry Ellsworth through the area that included Payne County, and he wrote a book, *A Tour on the Prairies*, describing his adventures. *A Tour on the Prairies*, published in 1835, is still in print. Describing the area that would become Payne County, Irving wrote, "We now came once more in sight of the Red Fork [now called the Cimarron], winding its turbid course between well-wooded hills, and through a vast and magnificent landscape."

Commissioner Ellsworth's journal also provides fascinating details about the landscape of what was then called the "far west." On October 20, 1832, he wrote, "My late traveling companion, Doct O Dwyer says, Eden was here, and not on the Euphrates . . . 'Adams paradise was in these praries [*sic*].'!!" At the time that observation was made, the group was somewhere in eastern Payne County, not far from where small towns like Ingalls, Ripley, and Mehan would be established.

However, with the passage of time, change was inevitable for the land along the Cimarron. In the 1880s, David L. Payne led the boomer movement to open these unassigned lands to settlement. At the same time, large ranches were leasing land from the Native Americans. The Berry Brothers Ranch covered an area from north of the Cimarron River to south of Pawnee on the Pawnee Indian Reservation—an estimated 60,000 acres. Everything changed when the land was opened to homesteaders, beginning with the historic land run of 1889.

On April 22, 1889, homesteaders eager for new opportunities settled the area with a land run. Towns like Stillwater, Perkins, and Ingalls were established. Later Cushing, Yale, and Ripley were added when the run of 1891 opened the Sac and Fox Reservation to settlement. Meanwhile Stillwater prospered as the county seat and home of Oklahoma Agricultural and Mechanical College, now Oklahoma State University. Many small towns in Payne County started with great hopes for the future but are now represented by only a few houses—or less.

In the beginning, though, anything was possible, and this is the story of people who truly believed that. Billy McGinty left home at the age of 14 to work as a cowboy, and he became one of Theodore Roosevelt's Rough Riders. He performed in Buffalo Bill's Wild West Show and was

the first cowboy filmed on a bucking horse. Eventually he settled down in Ripley with his wife, Mollie, and their three sons.

Otto Gray grew up on his family's farm southeast of Stillwater and northwest of Ripley. His father died in 1893, not long after the run of 1889, leaving his wife, Minnie, to live on the homestead and raise her family of seven children. Otto married Florence Powell in 1906, and the couple had a son, Owen. For a time, the small family lived in Wyoming, where Otto worked as a cowboy and Florence was a cook. They returned to the family farm southeast of Stillwater and worked hard to make a success of farming. By 1925, Otto also had a new and used furniture store in Stillwater. The Gray family's future seemed assured—and predictable. Otto would devote his attention to the store and grow old as a businessman-farmer living in the college town of Stillwater.

But that's not the way things turned out for either Otto or Billy. The lives of the two middle-aged men who seemed to have settled down changed dramatically beginning in the spring of 1925. That is when Billy McGinty's Cowboy Band performed over radio station KFRU, in Bristow, Oklahoma, and became the first western string band in the nation to perform over the radio. Billy was asked to lead the band because he was a legendary cowboy and Rough Rider who would give the band name recognition. After the band's first performance, telephone calls and telegrams poured into the station, with listeners from several states wanting to hear the cowboy band again.

Within less than a year, Billy's good friend Otto took over management of the band. Although Otto, like Billy, did not sing or play a musical instrument, he had learned the importance of showmanship. He was a trick roper, announcer, and publicist, as well as the band's manager. Otto took the band on the vaudeville circuit, and Billy soon returned to Ripley. Mollie and their three sons needed him at home.

The Oklahoma Cowboy Band met with amazing success over the air and on vaudeville. They performed in theaters in Kansas City, Chicago, Indianapolis, Cincinnati, and Pittsburgh drawing large crowds. At each city, they also played over the local radio stations, again drawing large audiences. Otto's wife Florence (always known as "Mommie" when she was with the band) sang, along with their son, Owen. Otto Gray and His Oklahoma Cowboys appeared on the cover of *Billboard* magazine in 1931, the first western band to appear on the show business magazine's cover. In the early 1930s, other bands began to imitate the Oklahoma Cowboy Band. Otto threatened legal action against the imitators and was successful in one case, but in the end, he settled for using the slogan "Often imitated, never duplicated."

By 1935, the Oklahoma Cowboy Band was feeling the effects of changes in the economy and in the nation's culture. The Depression was taking its toll, and movies were becoming more popular than vaudeville as entertainment. The band had its greatest success on vaudeville, and vaudeville was on the decline. In 1936, the band called it quits.

The combination of showmanship, folk music, and western themes and attire brought success to Billy and Otto at a time when commercial country music was in its formative stages. Up to that time, southern folk music in America was called hillbilly music, but with the inclusion of the cowboy image and themes, the music came to be called country and western, and later just country. The western element in country music, however, remains strong. The use of the cowboy image in country music continues, with many country musicians wearing cowboy hats and boots and singing about western themes.

The first band to wear cowboy attire and sing about western subjects before a national audience began as Billy McGinty's Cowboy Band and later became Otto Gray and His Oklahoma Cowboys. Throughout the band's remarkable history, it was often simply called the Oklahoma Cowboy Band. It was the band that set the stage for all the country and western bands that followed.

One

LIFE ALONG
THE CIMARRON

In Payne County, the Cimarron River, winding across the bottom third of the county, has been a major landmark since long before settlement. In the early days after the land run of 1889, ferries took travelers across the river. Even after bridges were built, the river still exacted a price from the towns of Ripley and Perkins, as periodic floods washed away the bridges and cut off communications and commerce.

Floods were not the only hazards faced by the early settlers. In the years immediately following settlement, law and order were not yet established, and the outlaw gang led by Bill Doolin and Bill Dalton made the small Payne County town of Ingalls its headquarters. A deadly gunfight between the Doolin-Dalton gang and U.S. marshals erupted in Ingalls on September 1, 1893, with three marshals and two bystanders losing their lives. To the relief of the law-abiding citizens in the area, all of the outlaws were eventually captured or killed.

The settlers worked together to build schools and churches. Businesses were established in even the smallest of towns, and newspapers helped to bring a sense of community to those who lived in this new country. And always there was the social support provided by churches, schools, and other organizations. Music frequently brought the residents of the area together too. Dances were common, and people gathered informally to play the music of their ancestors, which was often the music of Appalachia and the South. Cowboy ballads too were a part of the heritage of the settlers along the Cimarron River.

It was one such local band that gave rise to Billy McGinty's Cowboy Band, also known as the Oklahoma Cowboy Band. Ripley's "old-time fiddlers," led by Frank Sherrill, provided the musicians for a new form of entertainment: radio. Named Billy McGinty's Cowboy Band because of McGinty's fame as a Roosevelt Rough Rider, the band first played over radio station KFRU in Bristow, Oklahoma, in the spring of 1925. This was the nation's first radio broadcast by a western string band.

New York
Jan 1851

Washington Irving

Sunnyside Dec 15th 1851.

In Payne County, the Cimarron River flows through a region of Oklahoma called the Cross Timbers. One of the earliest descriptions of the Cross Timbers was written by Washington Irving, America's first internationally acclaimed writer. At the time, the river now known as the Cimarron was called the Red Fork. In 1832, Irving accompanied Indian Commissioner Henry Ellsworth on an expedition to Indian Territory. Irving's vivid description of the land he traveled through, published in A *Tour on the Prairies*, describes what the country was like before settlement.

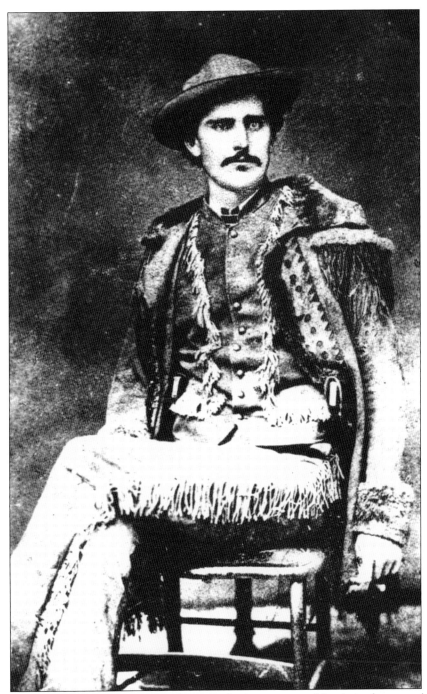

David L. Payne led the boomer movement to settle the unassigned lands in the central part of Indian Territory. He was a charismatic leader who believed the land was public domain and open to settlement according to the homestead laws of the United States. The federal government at first disagreed, but in the end, the arguments of the boomers prevailed. Payne County was named in honor of Payne, who was known by many as the "father of Oklahoma." (Courtesy Research Division of the Oklahoma Historical Society.)

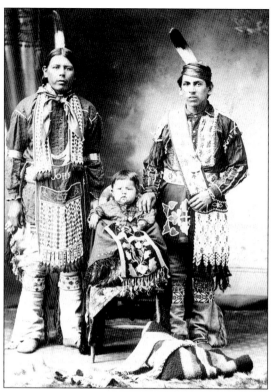

After the Civil War, the Sac and Fox Indians were moved to Indian Territory. Originally from the woodlands of the Northeast and upper Midwest, the Sac and Fox were relocated to what is now central Oklahoma. A part of the Sac and Fox Reservation south of the Cimarron River later became a part of Payne County. The Sac and Fox shown here are identified as the Grant Brothers. The photograph was taken by H. C. Chaupty, Oklahoma Territory. (Courtesy Research Division of the Oklahoma Historical Society.)

This photograph is identified as a Sac and Fox allotment camp. Before their land was opened to settlement in 1891, the Native Americans living on the reservation were given individual allotments of land. The Iowa reservation, south of Perkins in Payne County, was also opened to settlement in the run of 1891. (Courtesy Research Division of the Oklahoma Historical Society.)

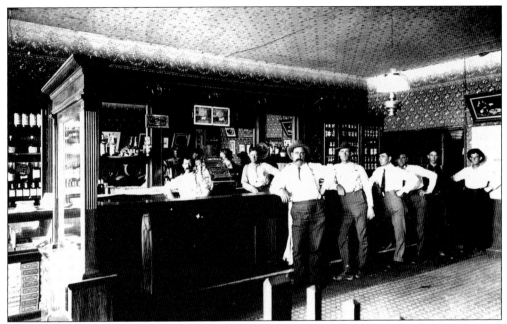

In the early 1890s, Ingalls, 10 miles east of Stillwater, became a refuge for the outlaw gang headed by Bill Doolin and Bill Dalton. Near the rugged hills north of the Cimarron River, Ingalls provided the outlaws with a sanctuary between bank and train robberies. The Ransom and Murray Saloon was a favorite meeting place for the outlaws.

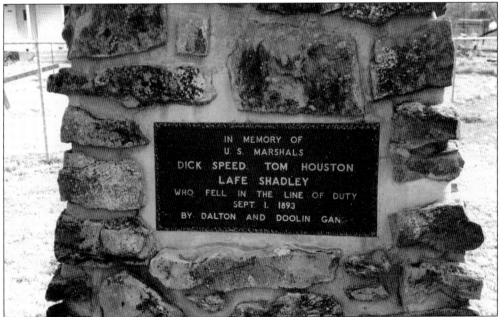

On September 1, 1893, a wagon loaded with deputy U.S. marshals attempted to arrest the Doolin-Dalton gang in Ingalls. A fierce gun battle left three marshals and two bystanders fatally wounded. "Arkansas Tom" was captured, but the rest of the gang escaped—temporarily. Eventually all of the gang members were captured or killed. This monument in Ingalls pays tribute to the three fallen lawmen Dick Speed, Tom Houston, and Lafe Shadley.

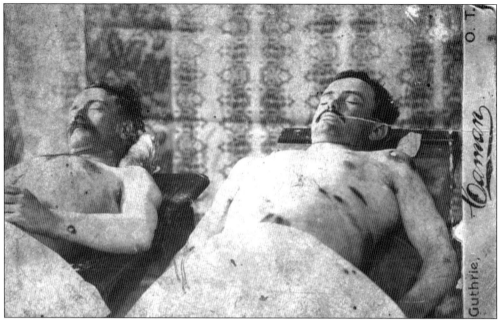

Doolin-Dalton gang members George "Bitter Creek" Newcomb and Charlie Pierce were killed at the Ingalls home of Bee Dunn, who had previously given the outlaws shelter from the law. The circumstances of the deaths were unclear, but the Dunn brothers, Dal, John, and Bee, claimed the rewards for the deaths of the two outlaws.

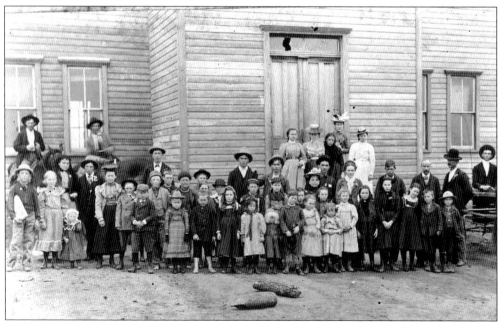

After the dramatic gunfight between the outlaws and the lawmen, life went on for the residents of Ingalls. They had businesses to run and children to educate, and they soon completed this schoolhouse. However, Ingalls eventually lost its stores, school, post office, and most of its residents. People in the Ingalls area, though, continue to have a strong sense of community, holding meetings at the community center and hosting annual reunions.

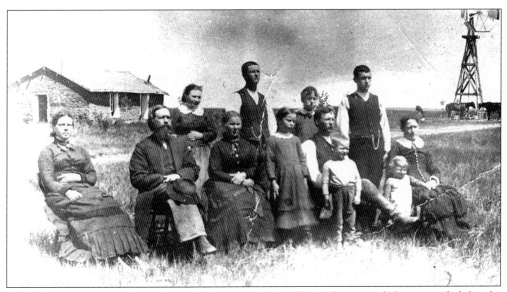

Jacob Pickering, an early settler and physician in Ingalls, is shown with his extended family. While Pickering was an upright citizen, some of those he treated were not so law-abiding. Among his patients were the outlaws Bill Doolin and George "Bitter Creek" Newcomb. His daughter Mary Emily "Mollie" was 16 at the time of the photograph. She later married Rough Rider and champion cowboy Billy McGinty, whose father also homesteaded near Ingalls.

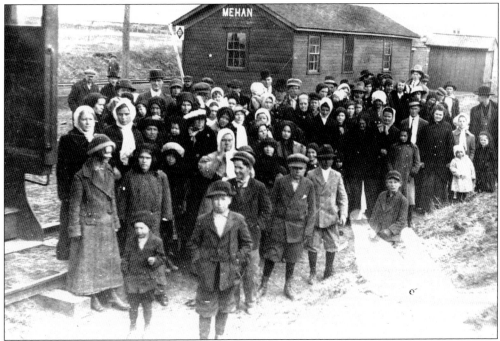

Mehan got its start in 1900 when the Eastern Oklahoma Railway established a depot and a town site on land belonging to John and Elizabeth Catharine (E. C.) Mehan. The rail service ended when the railroad bridge across the Cimarron River was washed out. Like many other small towns in Oklahoma, Mehan found that when the railroad was gone, it was hard for the town to survive. (Courtesy Cunningham Collection, National Cowboy and Western Heritage Museum.)

This is the house on the land homesteaded by Otto Gray's parents, southeast of Stillwater. This photograph, which was taken about 1900, shows, from left to right, Otto, Minnie (mother of the family), Harry, Elsie, Minna, Charley, and Linas. Ralph is sitting in the wagon. Thomas, the father of the family, died in 1893. (Courtesy Cunningham Collection, National Cowboy and Western Heritage Museum.)

Sooner Valley School was located one mile north of the small railroad town of Mehan. The term *sooner* refers to someone who arrived illegally before the land run, and in fact, John Mehan was wounded in a fight with a sooner when he staked his claim near where the school was built. (Courtesy Vicki George.)

Owen Gray, who was born in 1908, was a student at the Sooner Valley School. His parents, Otto and Florence, lived on the family homestead a mile north of the school. As most children did at the time, Owen probably walked or rode his pony to school. (Courtesy Vicki George.)

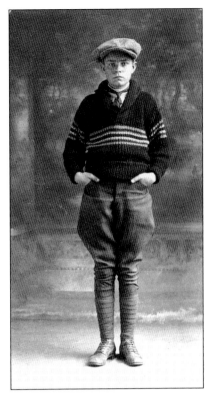

One year after the April 22, 1889, opening of the unassigned lands, Stillwater was the county seat of Payne County and on its way to securing the state's land-grant college (now Oklahoma State University). In 1884, the boomers had attempted to settle near Stillwater Creek, but they were sent back to Kansas. Their dream of a town site near Stillwater Creek was now a reality. (Courtesy the Sheerar Museum, Stillwater, Oklahoma.)

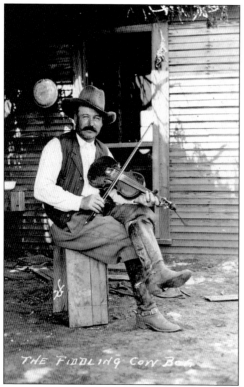

Cowboys and music seemed to go together in the Ripley, Ingalls, and Mehan area. Many of the cowboys had worked for the ranches that were there before the settlers. The Berry Brothers ranch was north of the Cimarron River, the Bar X Bar was to the northeast, and the Turkey Track was south. This photograph of Al Case of Ingalls identifies him as the "Fiddling Cow Boy."

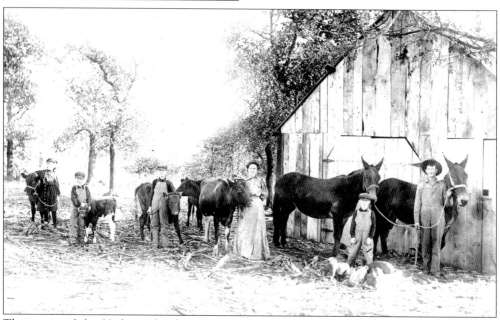

This scene of the Heilman family near Ripley suggests both the importance of livestock to the family and the probability that each family member had a role to play in maintaining the farm. Much of the land north of Ripley was, and is, best suited for raising livestock. The family members are identified as, from left to right, Hazel, Orion, Herschel, Dell (mother), Myrick Ray, and Charlie (father).

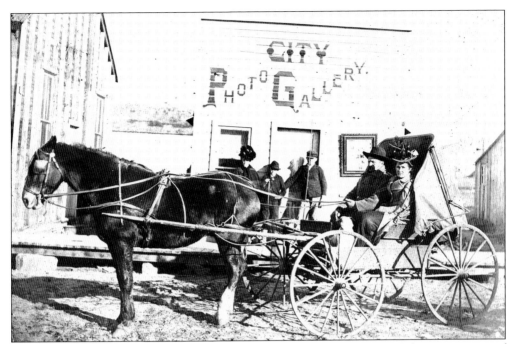

The people in this photograph, although not identified, remind one of the importance of photography in recording those early years after settlement. Some of the settlers kept journals, but most relied on letters and photographic images to aid in remembering their lives. Dale Carothers was the Ripley citizen who saved this photograph.

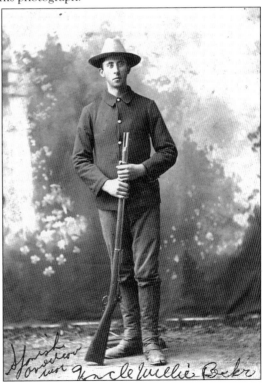

This soldier, who served in the Spanish-American War, is William John Becker, born in 1877. He died of tuberculosis in 1905 and is buried in Stillwater's Fairlawn Cemetery. Although many Americans did not directly feel the effects of the Spanish-American War, which was fought in 1898, Oklahoma contributed many soldiers to the effort. Those like Billy McGinty who joined the First U.S. Volunteer Cavalry were known as Rough Riders.

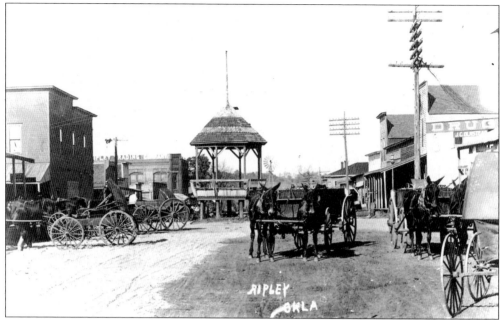

This street scene of early Ripley shows the town bustling with activity. The town was established in 1900 on the new route of the Santa Fe Railroad through Payne County. The railroad gave birth to Ripley, and the town honored its parent by naming the new town for the president of the Santa Fe Railroad.

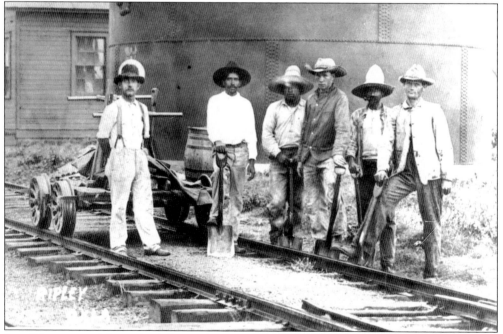

Jose Rivas, second from the left, was born in Mexico in 1870. He worked for the Santa Fe Railroad as the foreman of a crew that laid track through Payne County. However, after he got to Ripley, he quit his job with the railroad and went to work on the Tom Berry ranch west of town. Rivas died in Edinburg, Texas, at the age of 87. (Courtesy Teresa Garza.)

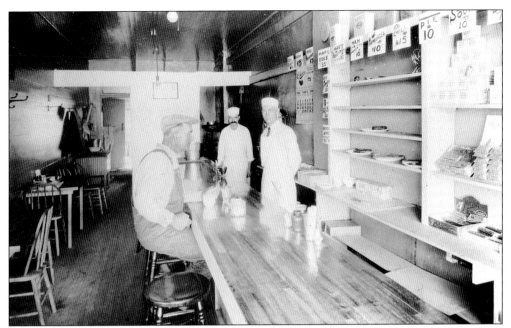

Before long, Ripley had all the ingredients of a small pioneer town: a post office, businesses, churches, doctors, a school, a newspaper, and a café. What they did not have yet was a bridge across the Cimarron River. Although there was a railroad bridge and a ferry was available, a bridge for wagons, horses, and people was not begun until 1909.

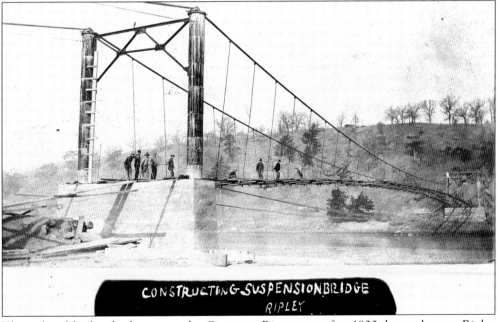

CONSTRUCTING SUSPENSION BRIDGE
RIPLEY

The railroad built a bridge across the Cimarron River soon after 1900, but as long as Ripley residents had only the ferry for crossing the Cimarron River, they felt cut off from Stillwater, the county seat, and other centers of commerce north of the river. In addition, rural residents north of the river found it more difficult to travel to and shop in Ripley. Finally in 1909, construction of a suspension bridge over the Cimarron River was begun.

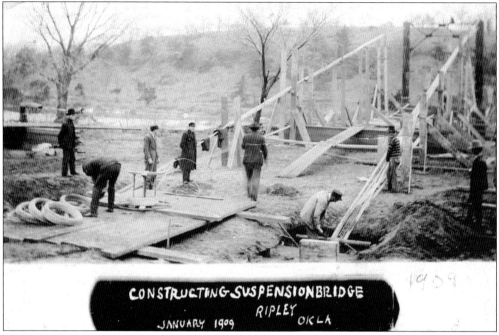

The entire community of Ripley took an interest in the new bridge, which was important to the town's survival. The building of the bridge was considered a major event in the town's history. The small railroad town of Ripley had big plans for the future.

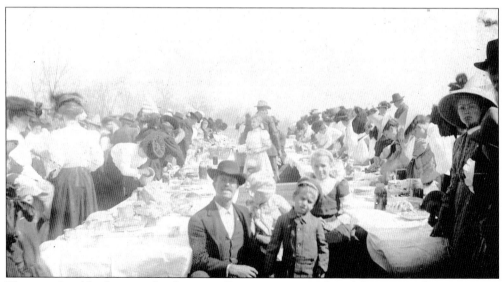

The completed bridge over the Cimarron River was a cause for celebration, and a community dinner marked the completion of the bridge. The river was an important part of the settlers' lives, and they were learning how to live with it.

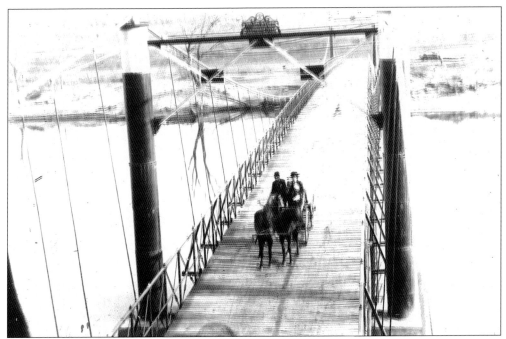

Once the bridge was completed, Ripley residents had access to towns like Mehan, Ingalls, Yale, and Glencoe, as well as to Stillwater, the county seat. The structure was a source of pride for the young community, and its completion would bring economic benefits to the town.

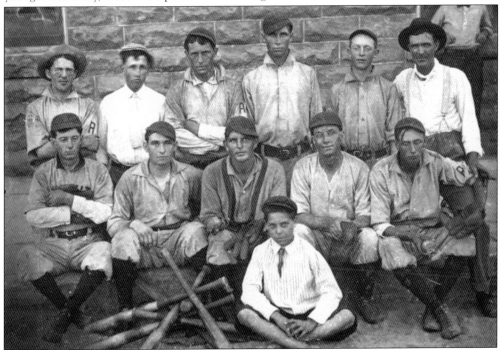

In the early part of the 20th century, baseball was a sport that drew communities together. The only person in this group who is identified is the boy sitting in the front. The inscription on the back of the photograph indicates the "smallest boy is Paul Luce, Ripley, OK."

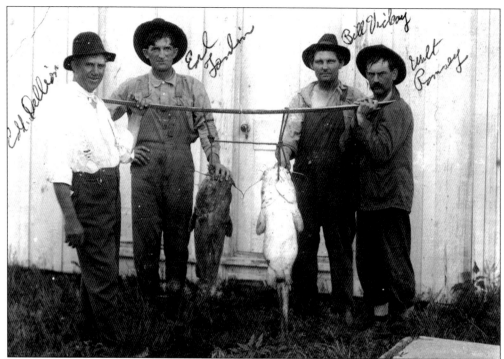

These fishermen from Ripley proudly display their catch: two large catfish from the nearby Cimarron River. They are, from left to right, Edd Dellion, Earl Tomlin, Bill Vickrey, and Walt Ramsey. Vickrey's father owned a blacksmith shop in Ingalls when the town was a haven for Bill Doolin and his gang. After the gunfight between the marshals and outlaws, Vickrey moved his blacksmith shop to Ripley.

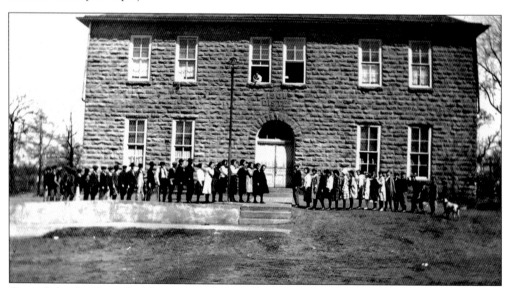

One of the first large buildings erected in Ripley was the town's school. Education for their children was a priority for the families of Ripley. The school promoted a sense of pride among the residents of the town and provided events that entertained everyone, not just the parents of the students.

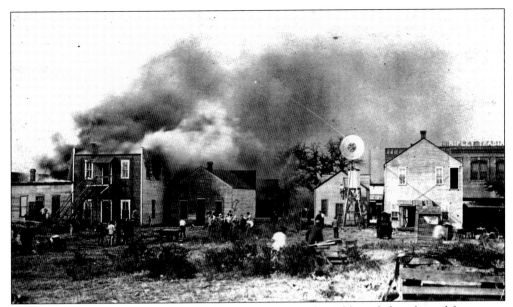

Often the wood buildings in a new settlement were erected quickly and cheaply, and fire was an ever-present danger. This 1911 fire destroyed several Ripley businesses. It started on the second floor of a two-story wood building on Main Street and spread to the pool hall and other buildings across the street.

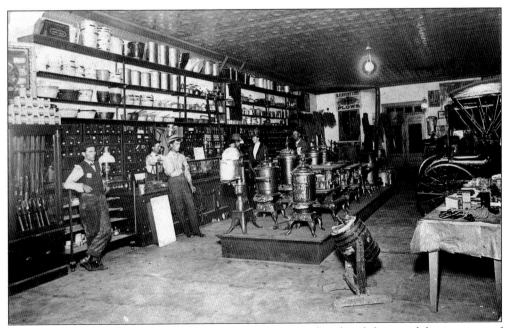

Ripley was home to Messecar's Hardware. Guy Messecar, who played the mandolin, was part of the original Oklahoma Cowboy Band, and like most of the original band members, he was from Ripley. As the band began playing farther from home, the original band members, who had jobs and businesses, were replaced with musicians who were able to travel.

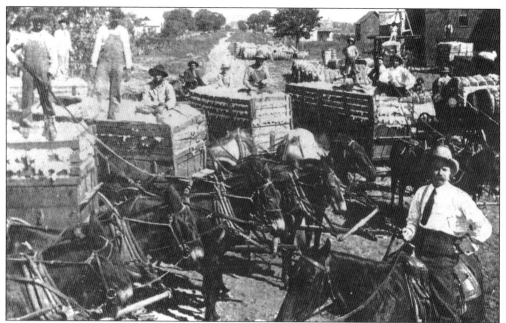

Although the Cimarron Valley was once the domain of cattle ranchers, by the early 1900s cotton was king. Here wagons loaded with cotton are lined up at the W. H. Coyle cotton gin in Ripley. The largest cotton farmer in the area, Brian Morehead, farmed near the small town of Clayton, three miles west of Ripley. Clayton was established in 1889 but could not survive the development of Mehan, just two miles to the north.

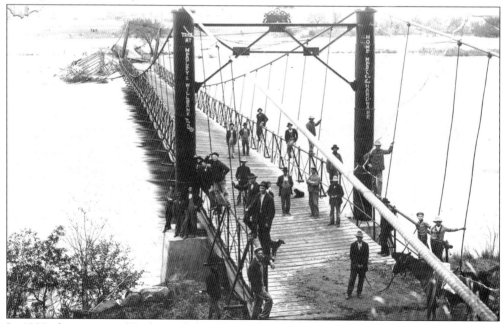

In 1909, the citizens of Ripley and the area celebrated the completion of the new suspension bridge across the Cimarron River. In 1912, they saw the floodwaters of the Cimarron River wash out a section of their fine new bridge. To the residents of the Ripley area, the river has always been both a friend and a foe.

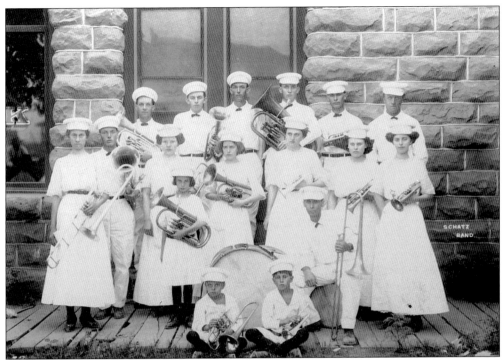

Organized band music in Ripley dates back to at least 1912, when Fenning Lyn Schatz introduced band music using cornets and other brass instruments. He taught all five of his children to play musical instruments, and with others, they formed the Ripley Cornet Band. The band, which played at pie suppers, parades, and fairs, continued until 1918.

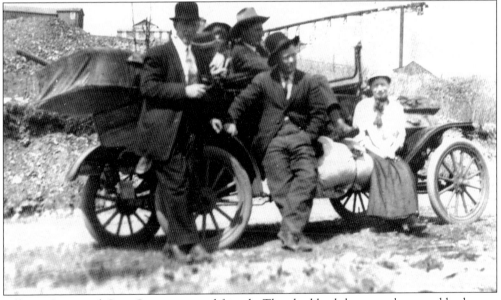

Billy McGinty and Otto Gray were good friends. They had both been cowboys, and both were quiet and easy going. In 1915, the two men and their families traveled to Colorado in a new Ford Model T. From left to right, the photograph shows E. O. Pickering, Florence Gray, Otto, Billy, and Mollie McGinty. For a time, Billy had a Ford dealership in Ripley.

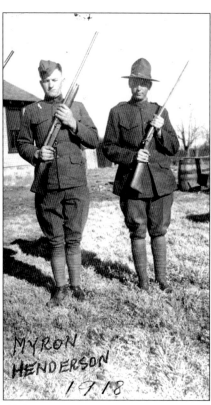

Myron Henderson, on the left, was a soldier in World War I. He returned to a country that was facing many changes. Automobiles were quickly replacing horses, and radio, phonographs, and movies were on the horizon. Rural Payne County would experience the changes as much as the rest of the country would. (Courtesy Neva Alsip.)

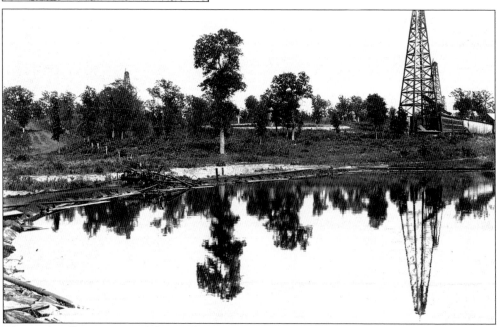

These oil wells were part of the Cushing-Drumright field, which in the early part of the 20th century was producing huge amounts of oil. Ripley was 10 miles to the west of Cushing and experienced some oil activity but never saw the oil riches of the nearby Cushing-Drumright field, which in 1915, provided 17 percent of the nation's oil.

This well was in the Cushing-Drumright field. The caption on the postcard indicates that the well is burning 60 million feet of gas per day. On the back of the postcard someone wrote, "This gasser is burning—located in the river bed—still yet unable to cap it or extinguish the flame—on acc't of the extreme heat & pressure."

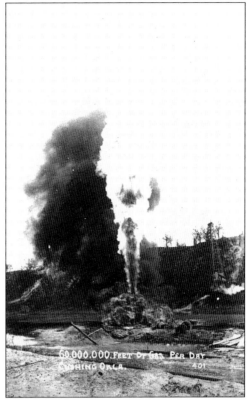

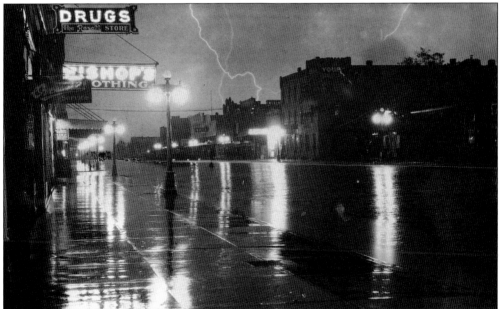

This dramatic photograph of a night view of downtown Stillwater in a thunderstorm was taken in 1917, but it seems much more modern. The dusty pioneer days were long behind the up-to-date college town, and both the town and Oklahoma Agricultural and Mechanical College were growing. (Courtesy the Sheerar Museum, Stillwater, Oklahoma.)

After his service with the Rough Riders in the Spanish-American War, Billy McGinty visited Theodore Roosevelt at Sagamore Hill, his home at Oyster Bay. McGinty's fame as a Rough Rider led to performances on horseback in New York City's Madison Square Garden. He went on to spend three years with Buffalo Bill's Wild West Show.

Wild West shows were highly popular in America from the 1880s through the 1920s. As a young cowboy in Oklahoma, Texas, and Arizona, McGinty had lived the stories of the Wild West, and as a Rough Rider, he showed great courage. This photograph is of McGinty when he was a member of Buffalo Bill's Wild West Show.

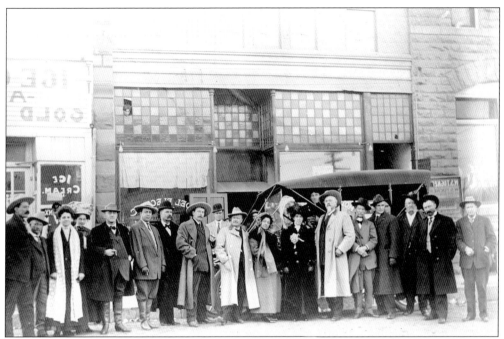

Pawnee, just north of Payne County, was the home of Pawnee Bill, also known as Gordon Lillie. Lillie and his wife, May, formed a Wild West show in 1888, which was joined with that of Buffalo Bill in 1908. The two showmen are in the middle, wearing light-colored coats. Pawnee Bill is on the left. They are in downtown Pawnee, along with potential investors from Philadelphia and St. Louis. (Courtesy Research Division of the Oklahoma Historical Society.)

Cowboy movie star Tom Mix, one of the biggest stars in Hollywood in the 1920s, was called the "King of the Cowboys." In the early 1930s, Mix and Otto Gray became friends when both were performing on vaudeville. (Courtesy Research Division of the Oklahoma Historical Society.)

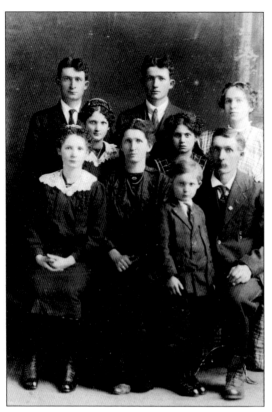

This photograph of the Jafek family, of Glencoe, was taken around 1915. The father, John, played the accordion, while his son Elgin played the accordion and violin. Elgin played some with the Oklahoma Cowboy Band 10 years later but could not leave his job and family to travel with the band. Seen here are, from left to right, (first row) Lottie, Anna (mother), Jonny, and John; (second row) Joe, Anna, Elgin, Abbie, and Martha. (Courtesy Dortha Mae Pepmiller.)

Otto Gray and his passenger (possibly his younger sister) prepare to go for a drive with this fine pair of horses. Gray grew up riding horses and was familiar with their care. However, when he became the leader of a cowboy band, automobiles, not horses, contributed to the success of the band. (Courtesy Vicki George.)

Two

Billy McGinty's Cowboy Band

There have been several accounts of how Billy McGinty's Cowboy Band got its start. The details may differ, but a common thread runs through them all. Essentially the band grew out of the happy combination of local musicians playing together and a conversation about the new medium of radio, which had only recently become available to the people of the Cimarron Valley.

Many years later, Billy McGinty's son Otto Wayne McGinty (usually called Jack) wrote about the beginnings of Billy McGinty's Cowboy Band. Jack said that George Youngblood, who sold radios in Ripley, was going to Bristow to pick up some new radios. Jack was going with him. At the Bevins garage, Youngblood found several musicians practicing, including Frank Sherrill and Jack. Jack, who was 18 at the time, started to leave, but Youngblood said he wanted to listen to the music awhile. Finally when they were on the way to Bristow, Jack said that Youngblood "was still thinking how good that western music would be on the air."

After they arrived at Bristow, Jack said, Youngblood talked to the manager of the station, who told him the group would have to have a sponsor, meaning a school or organization. After some discussion on their way home, the two decided that Jack's father, Billy, would be a good sponsor, since everyone knew him. He was one of Theodore Roosevelt's Rough Riders, a champion cowboy, and part of Buffalo Bill's Wild West show. Jack said, "When we get home, we'll tell him he is now the sponsor of Billy McGinty's Cowboy Band."

The band's first broadcast, over KFRU in Bristow, was in May 1925. Enthusiastic listeners began calling the station and sending telegrams in praise of Billy McGinty's Cowboy Band. One of the telegrams sent after a later broadcast, Jack said, was from Henry Ford. The band continued to broadcast from KFRU, which became KVOO (the "Voice of Oklahoma") in January 1926. In September 1927, KVOO was officially moved to Tulsa, and Billy McGinty's Cowboy Band was beginning to perform on vaudeville stages and play over radio stations in major cities across the Midwest.

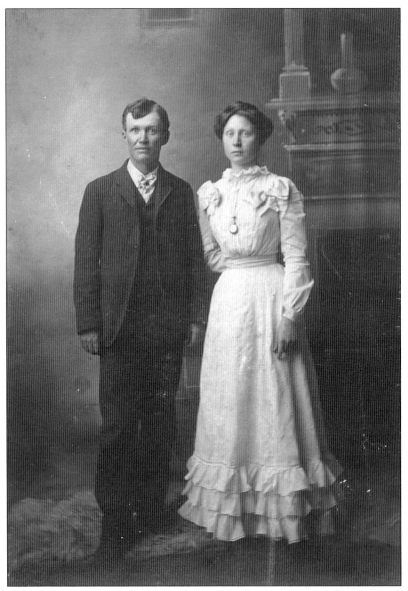

Although Billy McGinty traveled all over the world, when he married, he chose a hometown girl, Mary Emily Pickering, who was always called Mollie. She was the daughter of Dr. Jacob and Charlotte Ann Pickering, of Ingalls. Mollie was born in 1884 in Nebraska. The couple had three sons, Delmar, Otto Wayne (known as O. W. or Jack), and Clarence. Billy had a ranch, the Crossed Saber, in western Oklahoma before moving to Ripley. Born in Missouri in 1871, Billy was widely admired for his accomplishments and his courage. He was a Rough Rider with Theodore Roosevelt and a champion broncobuster who had worked for ranches throughout the Southwest. He was part of Buffalo Bill's Wild West Show for three seasons and was the first cowboy filmed on a bucking horse. By 1925, he had settled down and his adventurous days were behind him. However, Billy was going to embark on another chapter of his remarkable life. In May 1925, he became the leader of the first cowboy string band to broadcast over radio. Billy McGinty's Cowboy Band would go on to become the first cowboy band on vaudeville, finding success throughout the Midwest and Northeast. (Courtesy Mary Ruth Koutz.)

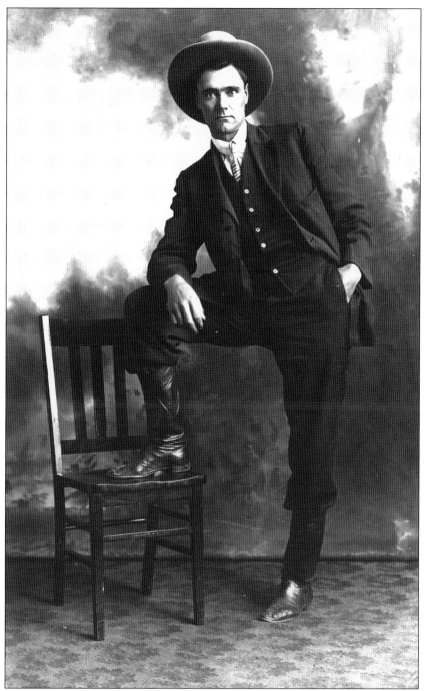

Otto Gray, who was born in 1884, grew up on his family's Oklahoma homestead, which is nine miles southeast of Stillwater and six miles northwest of Ripley. He often talked of his experiences in Wyoming, where he worked as a cowboy. He was adept at roping and performed rope tricks before audiences at fairs and rodeos. His wife Florence, who was born in 1888, was also a trick roper, and enjoyed singing. After farming and ranching on the home place for several years, Otto and Florence, with their son, Owen, moved into town. (Courtesy Vicki George.)

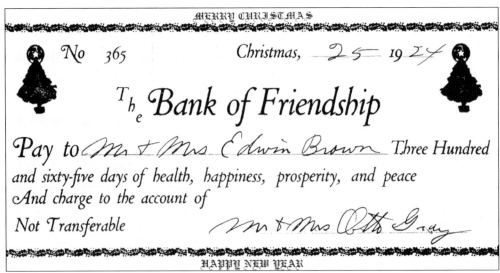

MERRY CHRISTMAS

No 365 Christmas, 25 1924

T_{h_e} **Bank of Friendship**

Pay to Mr & Mrs Edwin Brown Three Hundred
and sixty-five days of health, happiness, prosperity, and peace
And charge to the account of
Not Transferable Mr & Mrs Otto Gray

HAPPY NEW YEAR

By 1924, Otto and Florence Gray had moved to Stillwater and opened a store that sold furniture, both new and used. This card served as a Christmas greeting and a sign of friendship. Within the next year, the lives of Otto and Florence would change in ways they could never have imagined, and Otto's knack for publicity and making friends would play a big role in their new career. (Courtesy the Sheerar Museum, Stillwater, Oklahoma.)

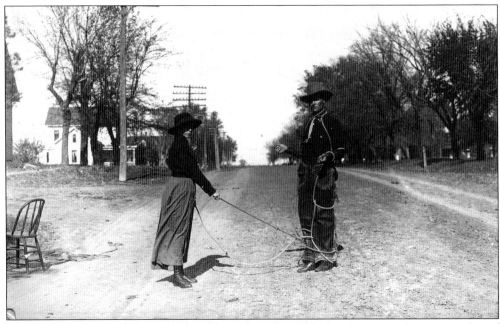

While Billy McGinty had traveled widely and performed before large crowds as a member of Buffalo Bill's Wild West Show, Otto and Florence Gray had experienced show business on a smaller scale. Otto appeared at the Laramie, Wyoming, Frontier Days, and both performed rope tricks for local events in Payne County. Their skill at roping came in handy when they began performing on the vaudeville circuit. (Courtesy Vicki George.)

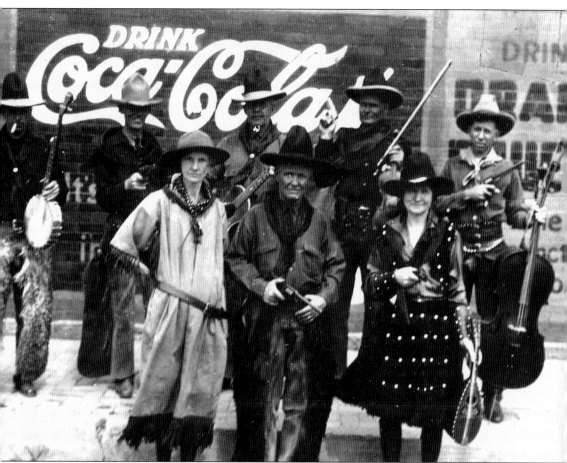

In May 1925, members of Billy McGinty's Cowboy Band made their historic first broadcast over KFRU in Bristow. It was said that the call letters KFRU stood for "Kind Friends Remember Us." The band members had their picture taken in front of another icon of American culture—a Coca-Cola sign. This was a tumultuous time in the development of radio, and KFRU soon became KVOO, which called itself the "Voice Of Oklahoma." Members of the very first Billy McGinty's Cowboy Band are, from left to right, (first row) Marie Mitchell, Billy, and his wife, Mollie; (second row) Harry Hackney, Guy Messecar, Paul Harrison, Frank Sherrill, and Ulyss Moore.

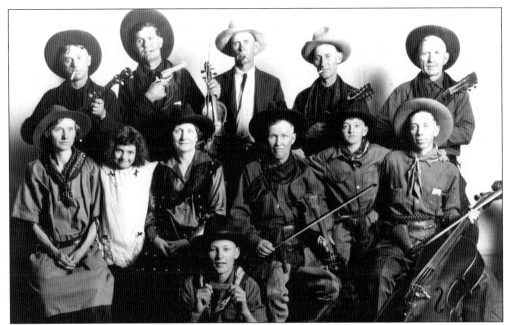

Another photograph of Billy McGinty's Cowboy Band was taken soon after the band's first performance. Seated in the front is Ernest Bevins, harmonica. The rest are, from left to right, (first row) Marie Mitchell, pianist; unidentified; Mollie McGinty; Billy McGinty; Paul Sharum; and Ulyss Moore, bass; (second row) Henry Hackney, banjo; Frank Sherrill, violin; Roy Munday, dance caller; Guy Messecar, mandolin; and Paul Harrison, guitar.

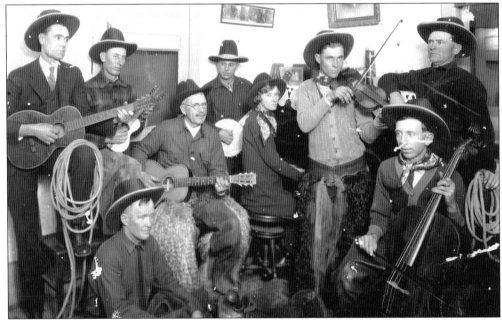

The musicians in Billy McGinty's Cowboy Band changed frequently. Band members in this photograph are, seated on the left, Billy and seated on the right Moore. Standing and seated are, from left to right, Otto Gray, Messecar, Harrison, Hackney, Mitchell, Johnny Bennett, and Sherrill. This is one of the earliest photographs showing Gray as part of the band.

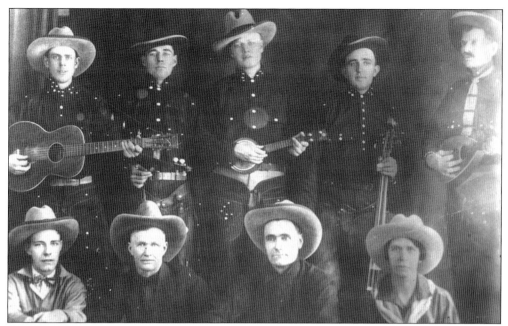

Soon Gray's wife Florence and their son, Owen, who was just 18 years old, joined the band. Seen here are, from left to right, (first row) Owen, McGinty, Otto, and Florence; (second row) Nealy Huff, Bennett, unidentified, unidentified, and Dave Cutrell. Otto, the cowboy turned businessman, was now the band's manager.

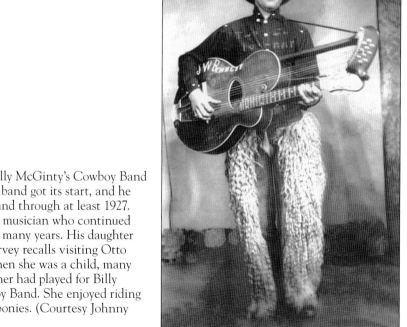

Bennett joined Billy McGinty's Cowboy Band not long after the band got its start, and he stayed with the band through at least 1927. He was a versatile musician who continued playing locally for many years. His daughter Reba Bennett Harvey recalls visiting Otto with her father when she was a child, many years after her father had played for Billy McGinty's Cowboy Band. She enjoyed riding Otto's miniature ponies. (Courtesy Johnny Bennett family.)

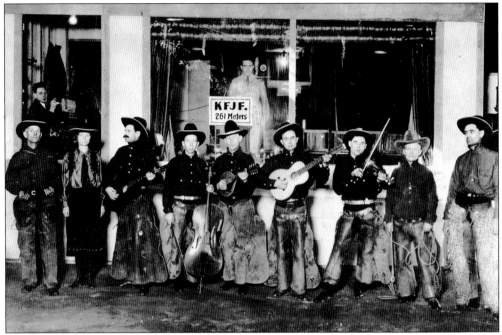

Radio station KFJF began broadcasting from Oklahoma City in 1924. In 1926, Billy McGinty's Cowboy Band broadcast over KFJF, just after Otto Gray, on the far right, had begun managing the band. Billy McGinty is shown standing next to Otto second from right. In the early 1930s, KFJF's call letters were changed to KOMA.

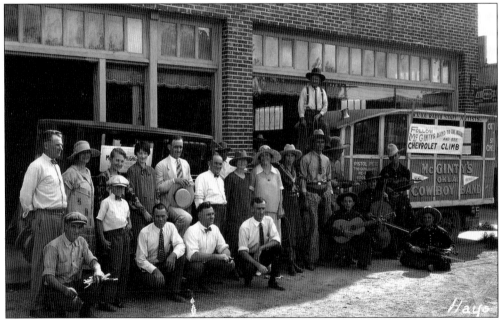

Billy McGinty's Cowboy Band soon had its own custom-built car for traveling. In addition to transportation, the car provided publicity. The cowboys of the old West, including McGinty and Gray, embraced a symbol of the future—the automobile. McGinty is sitting on the car, and Gray is standing in front of him, with Florence Gray next to him on the left.

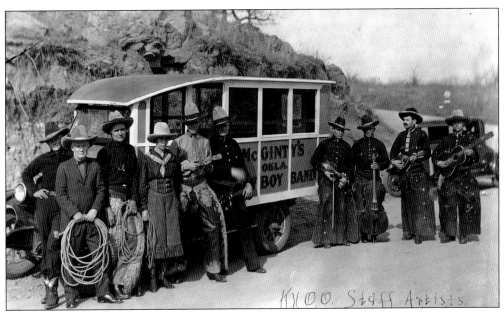

The bluffs on the north side of the Cimarron River provide a different backdrop for this publicity photograph of Billy McGinty's Cowboy Band. The *Bristow Daily Record* used the photograph when it announced that the band "has a contract to make talking machine records." The story continued, "Through the efforts of Roy C. Griffin, manager of KVOO, the Cowboy Band has become famous throughout the southwest."

These two pages from Otto's diary are typical of his management style. He kept track of things with as few words as possible, but he got the core information down—which is apparently all he needed. When he began making more money, he could afford to hire help in this area. (Courtesy Vicki George.)

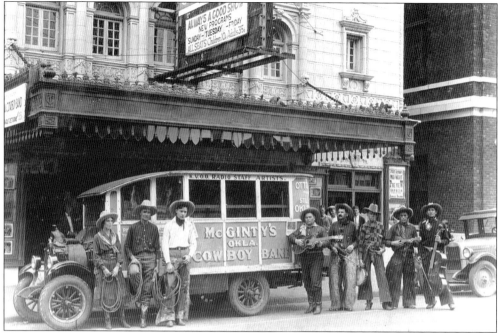

Advertised as KVOO Radio Staff Artists, the band played at the Orpheum Theater in Okmulgee. In this photograph, Florence and Otto Gray and their son, Owen, are on the left. The Orpheum, a beautiful theater that was a part of the vaudeville circuit in the 1920s, has been renovated and is still in use.

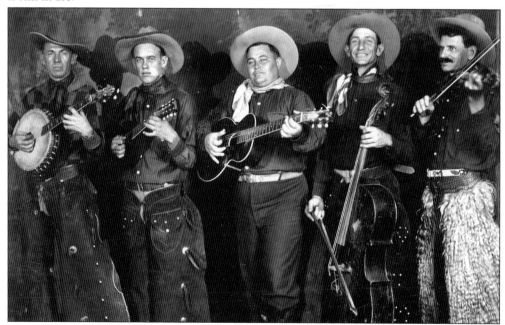

The members of Billy McGinty's Cowboy Band changed frequently. The first man on the left looks like Bill Stonehammer; the man to the right of him is unidentified. The man in the center is unidentified, and the man on the far right is the unmistakable Dave Cutrell. The man to the left of Cutrell looks like Chief Sanders, who played with Otto Gray in the early 1930s.

OTTO GRAY PRESENTS McGINTY'S
Okla. Cowboy Band

KVOO STAFF ARTISTS

ENTERTAINERS
FOR
Radio, Parks, Theatres
Recorders For
Okeh Phonograph Records

The above is a real bunch of cowboy entertainers and one of the most popular novelty bands on the road. They are expert ropers and riders as well as musicians.

For Information Address
Otto Gray, Stillwater, Oklahoma

This worn and tattered songbook contains many of the songs that the "Oklahoma Cowboys" sang or played. It also indicated the changing relationship of Billy McGinty and Gray. Gray was stepping to the front as manager of the band, while McGinty was becoming more of a figurehead. There was no resentment on the part of either, though, and the two remained lifelong friends.

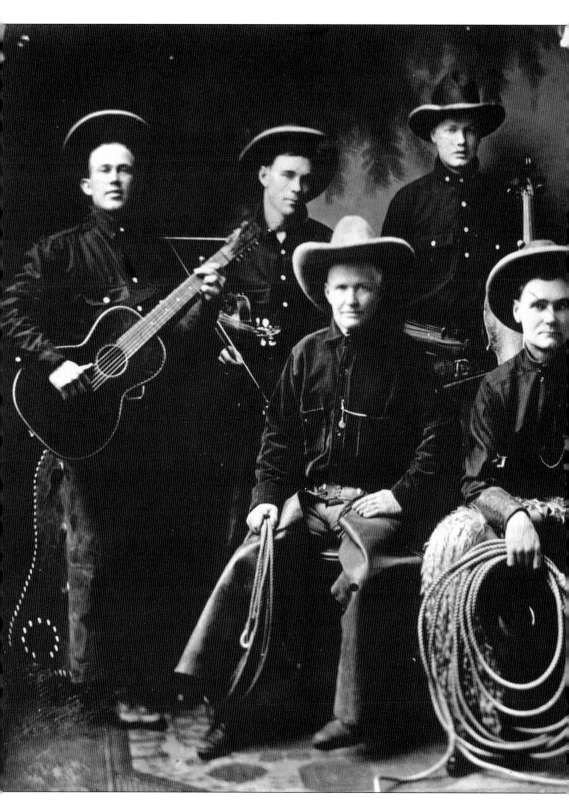

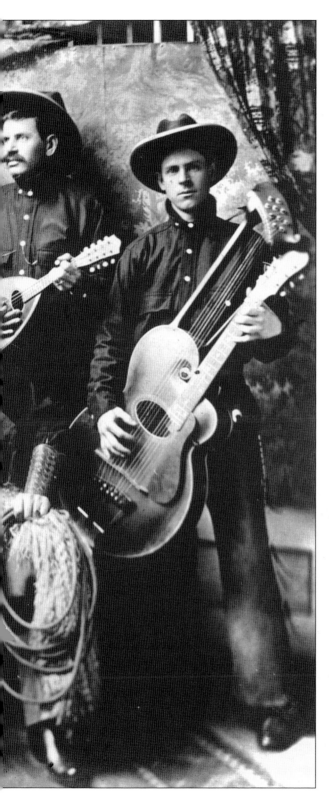

This photograph was used on one side of a Stillwater Chamber of Commerce card advertising Billy McGinty's Cowboy Band. The other side contained information about the band and Stillwater. Shown seated in front are Billy McGinty (on the left) and Otto Gray. Standing are, from left to right, unidentified, Johnny Bennett, unidentified, Dave Cutrell, and Nealy Huff. Cutrell was also called "Pistol Pete," and there are some who believe he was the inspiration for the Oklahoma State University mascot. However, Frank Eaton, of Perkins, is generally considered to be the model for the university's Pistol Pete.

McGINTY'S OKLAHOMA COWBOY BAND

The cowboys that broadcast the popular, old-time music which seems to be so well liked by all who hear them. Billy McGinty, "Col. Roosevelt's Rough Rider," and Otto Gray, trick and fancy roper, have been close friends for years and under their able management the "Oklahoma Cowboy Band" has gained quite a reputation over the United States, Canada and Mexico.

Billy McGinty saw service with Col. Roosevelt and was personally and favorably mentioned on several occasions. Billy did the first bronco-busting for the motion picture screen and won the championship at Southampton, N. Y., in 1910. He was a member of Buffalo Bill's Wild West Show for several years.

In May, 1900, Billy appeared in "The Miniature San Juan Hill" at Madison Square Garden, and was riding as wild a horse as ever came out of Texas. The horse tried in vain to unseat him, but failing in this, he made a sidewise leap against the arena fence and succeeded in breaking Billy's leg. Billy finished his "turn," however, and the thousands who were present didn't know that anything out of the way had happened until told about in the newspapers the next morning.

Billy McGinty, "Roosevelt's Rough Rider," Ripley, Ok.
Otto Gray, Manager and Announcer, Stillwater, Ok.
John Bennett, Violin

Dave Cutrell, Mandolin
Nealy Huff, Guitar
Alvin Mitchell, Piano
Ike Cargil, Bass Cello

Stillwater, Oklahoma

County seat of Payne county; population 8,700; bank deposits $2,570,634.85; municipal light and water plant; natural gas; good homes; lots of shade trees; good class of people; ten miles of paving; up-to-date stores; nine churches; five ward schools; one junior high; one senior high; one daily and two weekly newspapers; oil and gas production close by.

A SPLENDID HOME TOWN

Stillwater, Oklahoma

Home of the Oklahoma Agricultural and Mechanical College; 1925 enrollment 5,083; eight schools; thirty-eight departments; nine deans; 159 instructors; thirty-three in the Extension division staff; 1,000-acre farm; $4,500,000 state money invested in buildings, equipment and land; dormitory and cafeteria service available.

NO BETTER SCHOOL TOWN

THE CENTER OF THE POULTRY AND DAIRYING INDUSTRY

For Further Information Address Chamber of Commerce

Otto Gray helped to convince the Stillwater Chamber of Commerce that the Oklahoma Cowboy Band would be good for Stillwater. Supporters of KVOO radio had sent money to enable KVOO to build a 5,000-watt station at Bristow, but the station was moved to Tulsa. The chamber of commerce used Stillwater's refunded donations to print a folded card describing the band and its members, as well as the benefits of living in Stillwater. At the same time, a newspaper gave the following report about Billy McGinty's Cowboy Band: "Personnel of the band has undergone a great change recently, says Otto Gray, manager. It no longer is comprised largely of Ripley musicians, but now has in its membership musicians from Stillwater and other parts of Payne county." After that, Gray always identified Stillwater as the band's home.

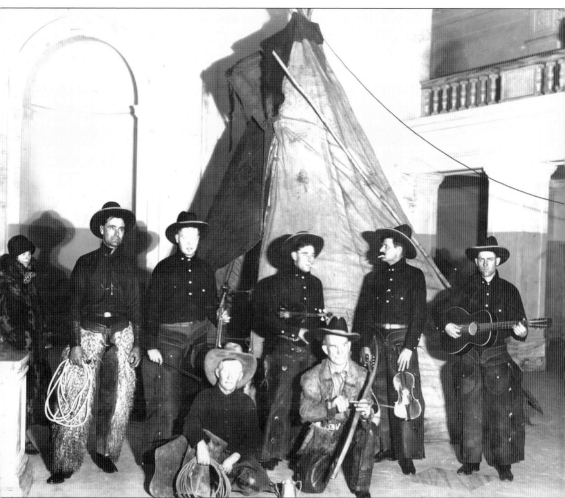

In early 1926, Billy McGinty's Cowboy Band entertained members of the Oklahoma Historical Society at their annual meeting in the statehouse. Billy McGinty, on the left, is shown sitting on the floor next to his friend Frank Orner, who is holding a bow and arrow. Orner was an early-day cowboy from the area of Perkins. He was a friend of the Iowa tribe, whose reservation was south of Perkins. Gray is standing on the far left. The woman in the background on the left is probably Florence Gray, who in the future would play a much larger role in the band.

Bill Stonehammer was with Billy McGinty's Cowboy Band for a period of about one or two years, sometime around 1926 and 1927. Since the membership of the band was fluid, it can be difficult to determine just who was with the band at what time. Sometimes a band member dropped out and joined the band again later.

In his song "Pistol Pete's Midnight Special," Dave Cutrell sang the following verse, which summarized the change in the band's leadership: "Now Mister McGinty is a good man, But he's run away now with a cowboy band . . . Now Otto Gray, he's a Stillwater man, But he's manager now of a cowboy band." It is probable that Mollie McGinty felt it was time for Billy McGinty, seen here, to come home.

Three

COWBOY MUSIC "ON THE AIR EVERYWHERE"

In January 1926, Otto Gray became the manager of Billy McGinty's Cowboy Band. In a few early photographs of the band from that time, Gray is shown with a guitar, but he soon exchanged the guitar for a lasso, since he and his wife Florence did trick roping, and Otto did not play the guitar particularly well. Florence, always called "Mommie" when she was with the band, was one of the first women to sing on stage or over the radio with a western band.

The Grays' only child, Owen, was 18 when he became a part of Billy McGinty's Cowboy Band. From 1926 until 1936, the three members of the Gray family were the unchanging core of the band. The other musicians changed fairly frequently, with some dropping out and rejoining the band later. The musicians apparently left the band without animosity. Several departing band members left photographs of themselves with written notes of friendship and gratitude to Otto Gray. Billy McGinty and Otto, who were friends before the band was formed, remained close friends throughout their long lives.

During 1926 and 1927, the band continued to play as Billie McGinty's Cowboy Band, but the band was clearly guided by Otto. In early January 1926, Otto arranged for the band to appear in Kansas City on the Orpheum vaudeville circuit and broadcast over WHB, a station associated with the Sweeney Automobile School. In 1926, the band played in towns in Oklahoma, but in 1927, the cowboys spent more time in the Midwest, appearing on the vaudeville circuit in Indiana, Ohio, and Pennsylvania. For audiences in those states, the cowboy band was a delightful novelty act, something they had never seen before. In an undated news clipping, WLW in Cincinnati announced that Billy McGinty's Cowboy Band was coming to town. The conclusion of the story was, "The cowboy band has been heard from many other leading radio stations and has been a popular vaudeville feature all over the country."

Sometime in late 1927 or early 1928, the name of the band was changed to Otto Gray and His Oklahoma Cowboys. However, the band was frequently called the Oklahoma Cowboy Band, and it's slogan was On the Air Everywhere, no matter what name was used.

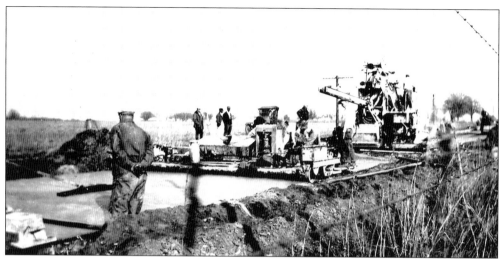

Just 50 years before this photograph was taken, the unassigned lands of Oklahoma were still the frontier. No farms, no settlements, and very few roads were to be found. The prairies were unplowed. With settlement, though, the countryside changed quickly, and when the Oklahoma Cowboy Band began its travels, the roads, both in Oklahoma and other states, would soon be ready for them.

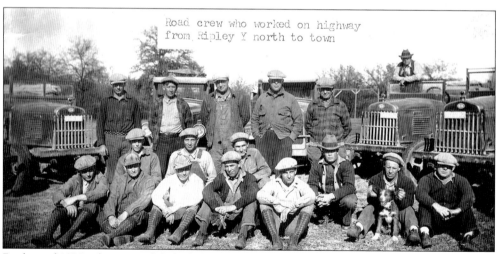

By the mid-1920s, the automobile had almost replaced the horse and buggy, and the improvement of roads was a priority for communities everywhere. Good roads made it possible for the Oklahoma Cowboy Band to travel long distances. This crew paved the road from Highway 33 north to Ripley, and they were proud of their work. Automobiles and improved roads played a crucial role in the career of the Oklahoma Cowboy Band.

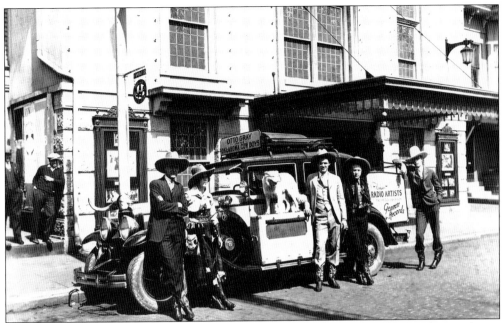

Otto Gray became known for his use of custom-built cars. This Cadillac with steer horns attached to the front was the first of several such automobiles. The white dog on the car, Duke, was the predecessor of Rex, a well-trained German shepherd who later became part of the band. From left to right are Otto, Florence Gray (who was always called "Mommie"), two unidentified band members, and Owen Gray.

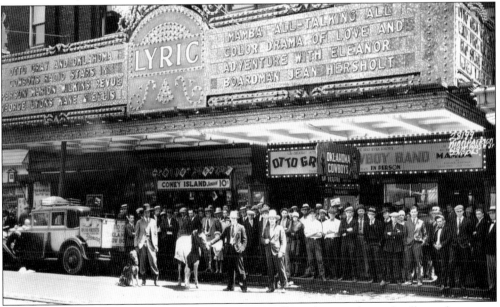

The Lyric Theater, in Indianapolis, began showing films along with vaudeville performances during the days of silent movies. Otto advertised the band's theater performances on his radio show, and the theater, in turn advertised his radio performances. Another form of advertising was to have a contest for children wanting to win a pony. The pony standing in front of the crowd is the prize in one such contest.

THE COWBOY'S LAMENT

As I passed Tom Shermans' barroom,
Tom Sherman's barroom quite early one morn,
I saw a young cowboy all dressed in his buckskins,
All dressed in his buckskins, all fit for the grave.

CHORUS

Go beat the drum lowly and play the fife slowly,
Go beat the dead march as they carry me along,
Take me to the prairie and place the sod o'er me,
For I'm a wild cowboy and know I've done wrong.

Oh, once in my saddle I used to go dashing;
Oh, once in my saddle I used to ride brave;
But I first took to drinking and then took to gambling,
Got shot by a gambler, now I go to my grave.

Go, gather around me a lot of wild cowboys,
And tell them the story of a cowboy's sad fate;
And warn them quite gently to quit the wild roving,
To quit the wild roving before it's too late.

Go, carry the news to my gray-headed mother,
Go, carry the news to my sister, so dear;
But there is another more dear than a sister,
Who'd bitterly weep if she knew I were here.

Oh, bury beside me, my knife and six-shooter,
My spurs on my heels, my rifle by my side;
And over my coffin place a bottle of brandy
That the cowboys may drink as I take my last ride.

Someone please bring me a drink of cold water,
A drink of cold water, the poor cowboy said;
But as they started, his soul had departed,
He'd gone on the roundup, and the cowboy was dead.

Otto Gray published several songbooks featuring the songs of his Oklahoma Cowboys. *Otto Gray Presents McGinty's Okla. Cowboy Band* was published in 1926 or 1927. *Songs: Otto Gray and his Oklahoma Cowboys* was published in 1930. *Old Time Songs* was published in late 1929 or early 1930. The songs include a mixture of the sentimental ballads that Florence Gray sang, traditional cowboy ballads, and the humorous songs that Owen Gray frequently sang. In *Old Time Songs*, the songs included were such favorites as "Midnight Special," "Old and Only in the Way," "Red River Valley," "Terrible Marriage," "The Letter Edged in Black," "The Dying Cowboy," and "The Cowboy's Lament." Otto's version of this traditional western ballad, shown here, differs from the more frequently heard "Cowboy's Lament," which begins "As I walked out in the streets of Laredo."

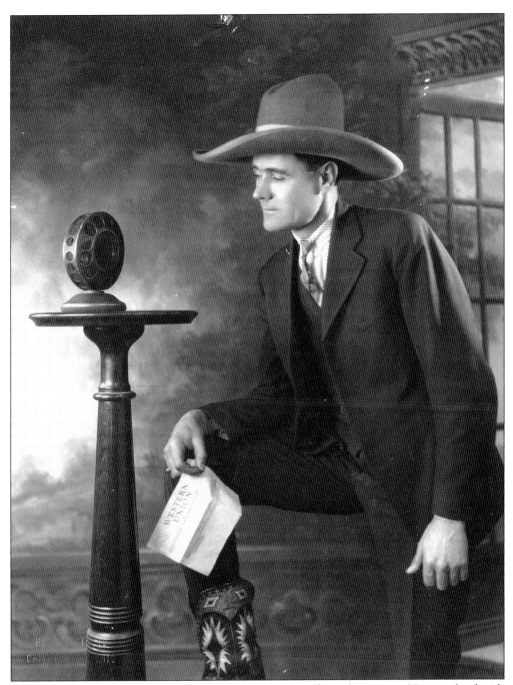

Otto served as the announcer for the band when they broadcast their music. He is credited with giving the first commercial over KVOO in Oklahoma when he promoted a hosiery company for the station. The story is told that Mommie tried to help him with his pronunciation of some of the words, but Otto said the listeners liked him the way he was, and he was apparently right. When Billy McGinty's Cowboy Band began playing for radio, in 1925, it was the only western band on the airwaves. By 1928, the band was playing over dozens of radio stations in the Midwest and East and were advertised as "radio stars." (Courtesy Vicki George.)

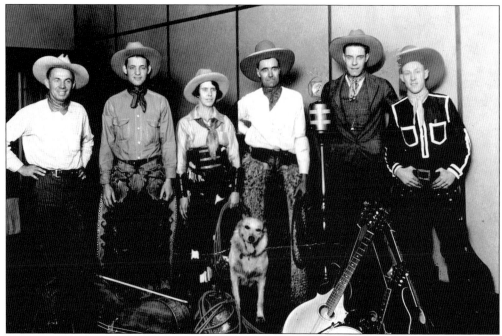

In 1927 or early 1928, the Oklahoma Cowboy Band consisted of, from left to right, Bill Stonehammer, Benjamin "Whitey" Ford, Florence "Mommie" Gray, Otto Gray, Owen Gray, and Bill Wedlin. Ford later became known as a comedian and country musician with the nickname of the "Duke of Paducah." The dog seated in the middle behind the musical instruments is Duke, a collie-shepherd mix.

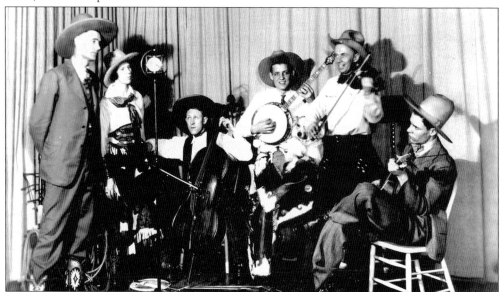

This photograph shows the band with their many instruments. Otto and Mommie did not play an instrument, but they had their own important roles. Otto was the manager, announcer, and trick roper, while Mommie did rope tricks and sang. She was the first woman to sing with a cowboy band on radio and vaudeville. Seen here are, from left to right, Otto, Mommie, Wedlin, Ford, Stonehammer, and Owen.

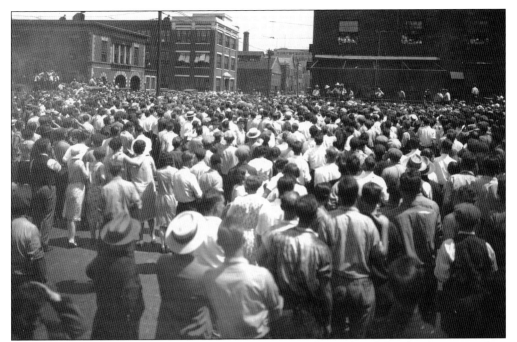

In the early 1930s, Otto Gray and His Oklahoma Cowboys played for this large crowd in Schenectady, New York, which is identified as a labor union. The cowboys are in the upper right. Unlike his fellow Oklahoman Woody Guthrie, Gray did not usually become involved in political issues, and the purpose of the rally is not known.

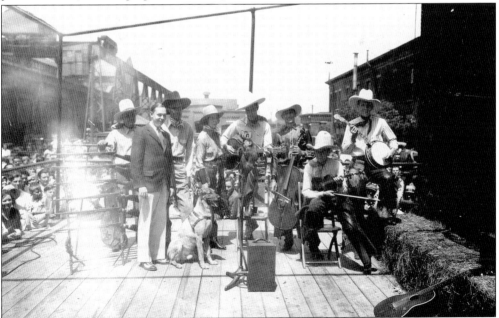

A closer look at Otto Gray and His Oklahoma Cowboys shows they are broadcasting over Station WGY, in Schenectady. The cowboys received a warm welcome when they appeared in Schenectady, and it is probable that their entertainment at the gathering helped to increase the size of the crowd.

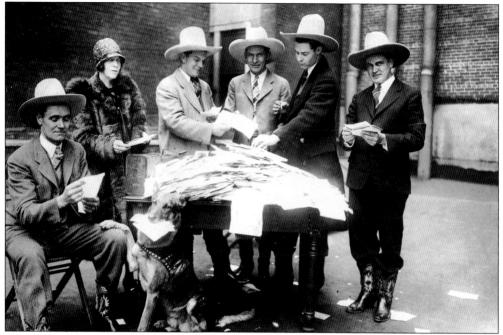

This photograph in the *Cincinnati Times-Star* on December 19, 1930, shows the band "looking over some of the mail that piles up for them during their absence from Cincinnati." From left to right are Otto Gray, Mommie Gray, Boots Purvis, unidentified, Owen Gray, and Rube Tronson. The newspaper noted, "Rex, being a wonder dog, holds his usual central position in the foreground of the picture.

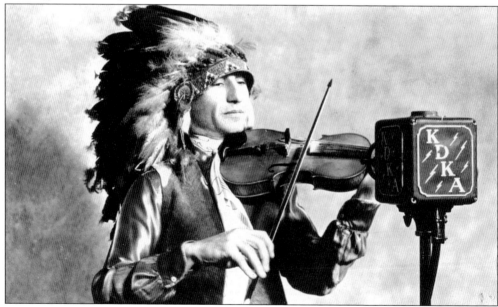

This photograph of "Chief Red Bird" is from the KDKA Artists Booking Service of Pittsburgh. In reality, this is Chief Sanders, a Cherokee who played the violin with Otto Gray and His Oklahoma Cowboys. It was not unusual for members of the band to have different names or nicknames as they played different roles in the band's stage and radio shows.

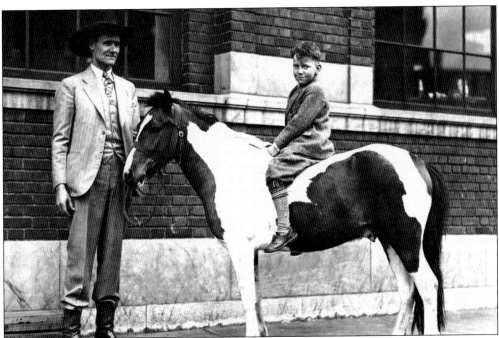

Frequently when Otto Gray and His Oklahoma Cowboys were scheduled to perform in a city, Gray publicized the appearance by giving away a pony as a prize in a contest for children. Sometimes the contest required the children to color a picture of the pony, and sometimes the children had to write a letter saying why they wanted the pony. The contests were frequently sponsored by the radio stations where the band performed, but newspapers and theaters sponsored the contests, as well. Gray is shown here with the winner of one of the contests, above, and below, Billy McGinty is shown with a pony waiting to be won someday by some lucky child.

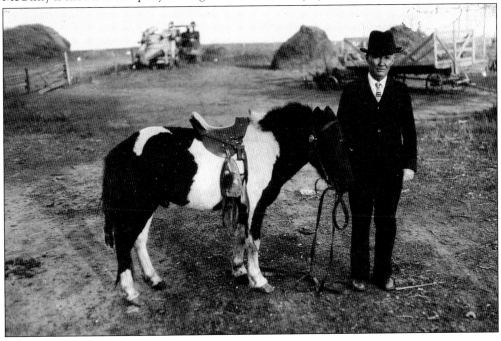

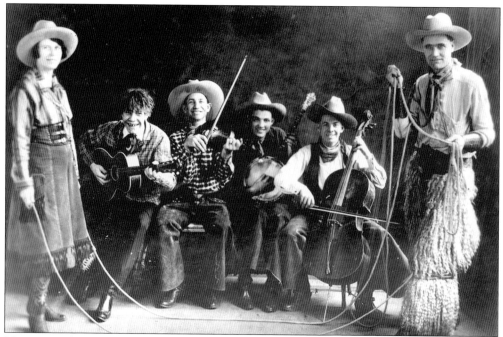

Mommie and Otto Gray's rope tricks were a part of the Oklahoma Cowboy Band's stage show. Mommie also sang, and sorrowful songs like "Oh, Where Is My Wandering Boy Tonight?" and "Drunkard's Lone Child" were popular with the audiences. This photograph shows, from left to right, Mommie, Owen Gray, Chief Sanders, unidentified, Bill Stonehammer, and Otto. (Courtesy Vicki George.)

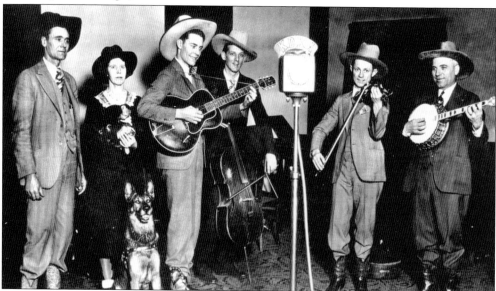

The band scheduled their radio broadcasts to allow them to appear on stage in the same area. A March 1929 news clipping from the band's scrapbook reported that "Otto Gray and his Cowboys, stage and radio attraction, will return to Station KDKA here next Saturday for an indefinite engagement. The orchestra will play theaters in the surrounding towns during its run at the local broadcasting works." (Courtesy Vicki George.)

OTTO GRAY

AND HIS

COWBOYS

Of Stillwater, Oklahoma

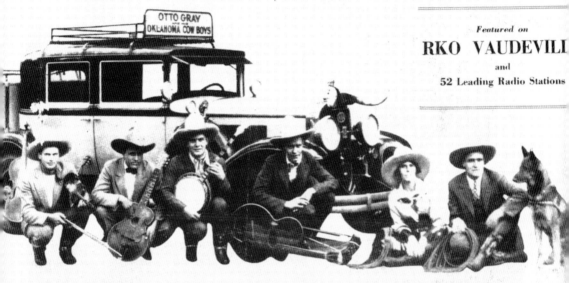

Featured on

RKO VAUDEVILLE

and

52 Leading Radio Stations

Compliments of THE COLUMBIA FARM NETWORK

This photograph was printed with the following caption: "Otto Gray and his cowboys, famous radio stars and vaudeville headliners, [are] coming . . . direct from their sensational success at WGY, Schenectady, together with four other greater Publix acts of vaudeville. Gray and his entourage are known to millions of radio fans through their broadcasting efforts from 52 of the leading radio stations of the country and the Columbia network." Later the Columbia network developed into CBS (Columbia Broadcasting System). The cowboys in the advertisement are, from left to right, Rube Tronson, unidentified, Boots Purvis, Owen, Mommie, Otto, and Rex.

OTTO·GRAY
AND HIS
COWBOYS
OF STILLWATER, OKLA.

Brunswick Recorders

Radio Broadcasters
featured from
WLS·KDKA·KVOO
WHB·WHAS·WOS
WLW·WTAM·WOWO
WHO·WFAA·KWWG
WDAF·WBAP·KFRU
KMOX·WJAD·WFBM

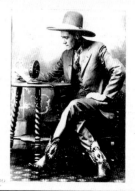

This postcard underlines the importance of radio to Otto Gray and His Oklahoma Cowboys. The band often played for hours over the radio, and Otto Gray once boasted that they could play for 18 hours without repeating a song. Owen Gray, his son, is on the lower left-hand side of the card, and Otto is on the lower right-hand side. (Courtesy Vicki George.)

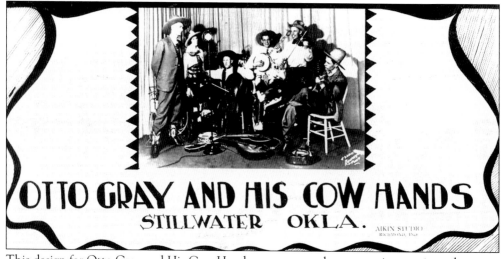

OTTO GRAY AND HIS COW HANDS
STILLWATER OKLA.

This design for Otto Gray and His Cow Hands was apparently an experiment, since the name was never used again. Gray had several different designs made at the same time by Aikin Studio in Richmond, Indiana. The band was always being remade, with changes in personnel, names, automobiles, and designs. (Courtesy Vicki George.)

In June 1930, the *Indianapolis Star* arranged for the Oklahoma Cowboy Band to entertain the children at the James Whitcomb Riley Hospital. The newspaper reported, "Otto Gray did trick roping while the other members accompanied him with old-time melodies on their fiddles, banjos and guitars. Then came several song numbers and some trick playing on the violins. At this point Otto and 'Mommie' Gray gave an exhibition of an old-time dance. Billy Knox was next with a series of shooting exhibitions. The program was concluded by the company presenting their favorite, 'The Dying Cowboy,' which was a 'show stopper.' In this, Rex the dog was one of the star performers."

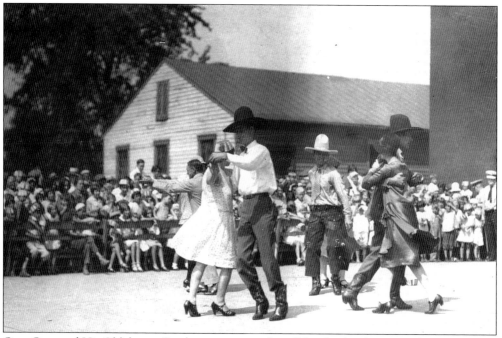

Otto Gray and His Oklahoma Cowboys entertained at all kinds of gatherings. The occasion for this celebration is not identified, but the exuberant joy of the dancers is clear. Community dances were common in rural Oklahoma in the early days after settlement, and Otto and Mommie Gray met at one of those country dances. (Courtesy Vicki George)

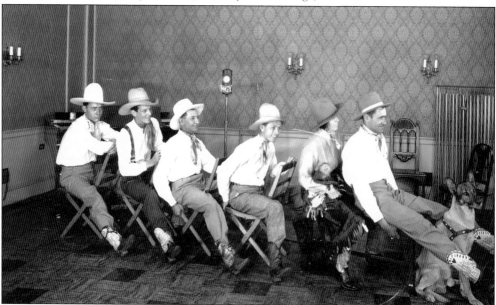

Even though the cowboys traveled in relative luxury, the vaudeville circuit could be demanding. Long hours of driving and long hours in front of the microphone were combined with stage shows and publicity activities. In this photograph, the band members seem to be having a good time performing for themselves. From left to right are Owen Gray, Wade Allen, Chief Sanders, Lee Allen, Mommie, Otto, and Rex. (Courtesy Vicki George)

When Richard E. Byrd made his first expedition to Antarctica in 1929, KDKA in Pittsburgh arranged for the Oklahoma Cowboy Band to broadcast their music to the expedition. A news story noted, "At 12:00 midnight, Otto Gray and his wife and cowboys and their dog, Rex, were presented to Commander Byrd and his expedition by radio over a space of 11,000 miles of land, water, ice and snow. Rex, the educated dog, sent messages in his own language to the dogs of the expedition and the men from the Western ranch played several of the old-time tunes." Rex was popular on stage, too. He is shown below with a miniature horse and a monkey. The monkey, called "Miss KDKA" or "Chip," is remembered by Otto's nephew Loren Gray as the one who tried to bite him when he visited his uncle.

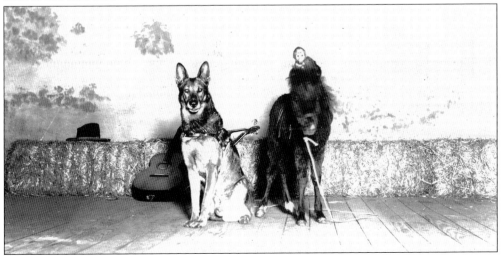

On November 14, 1932, the cowboys were scheduled to broadcast over the NBC chain at WGY in Schenectady, and Otto Gray had a plane take them from Newark to Schenectady. The plane had mechanical trouble and went down in a pasture near Geneva, New York. The pilot and the passengers were unhurt. Gray said this was the first time he had missed a radio program since the troupe began broadcasting. (Courtesy Vicki George.)

The passengers on the plane were Otto, Mommie Gray, Owen Gray, Wallace Schumann, Benjamin Ford (also known as Whitey Ford), and the dog Rex. The rest of the band left the evening before to drive to Schenectady. Reports of the plane crash varied from describing it as "a possible accident" that was "nothing more than an experience" to reporting that the musicians "narrowly escaped death." (Courtesy Vicki George.)

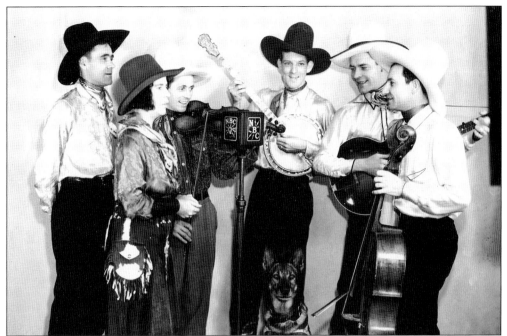

Otto Gray and His Oklahoma Cowboys are shown in a 1931 publicity photograph by photographer Harold Stein. Stamped on the back of the photograph is "NBC Artists Service, 711 Fifth Avenue, New York, N.Y." From left to right are Otto, Mommie, Lee Allen, Wade Allen, Owen, and Chief Sanders.

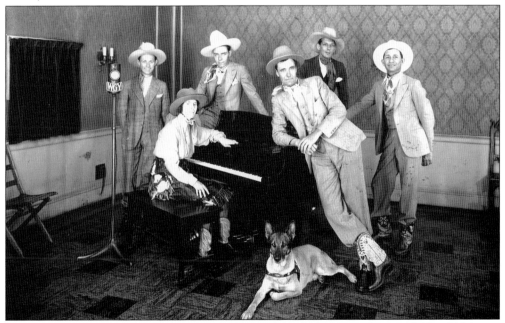

In this photograph taken at station WGY in Schenectady, Otto Gray and His Oklahoma Cowboys are shown without their musical instruments. Mommie is sitting at the piano, although the piano was rarely, if ever, a part of the band's stage or radio shows. Standing are, from left to right, Lee, Owen, Wade, and Chief Sanders. Otto is leaning on the piano in front.

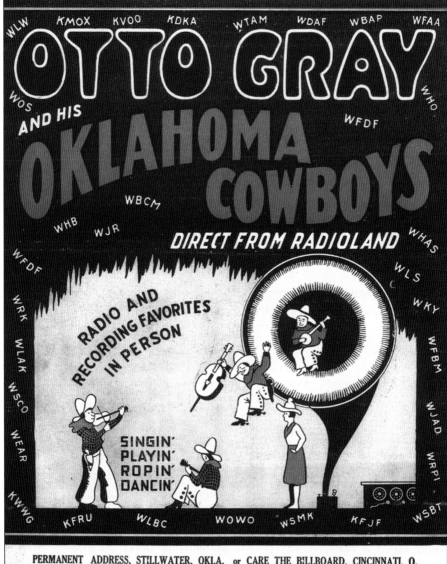

To promote Otto Gray and His Oklahoma Cowboys, Otto Gray had colorful advertisements printed in magazines and on "window cards," 14-by-22-inch cardboard advertisements that could be placed in a store or shop window or tacked to a telephone pole. In the 1920s, Frank Bower, of Fowler, Indiana, had a successful printing company. On the advice of a theatrical booker, he added "show printing" to his business, which became Bower Show Print. He designed and printed many posters and advertisements for the Oklahoma Cowboy Band, including this one.

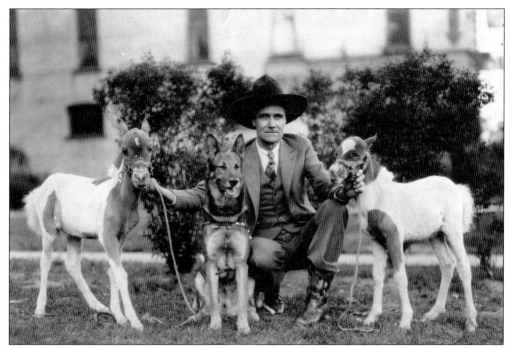

Gray is shown with two "Arabian midget horses" and his dog Rex. Gray said that he refused an offer of $5,000 each for the horses, named Dot and Tot. "I get all sorts of offers for those little horses," Gray said, "but I'm going to keep them. They are too good an attraction."

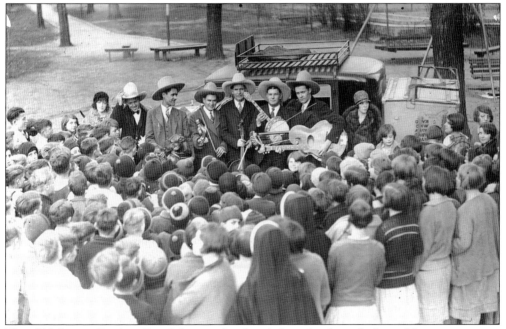

The Oklahoma Cowboy Band frequently played for schools and charitable organizations. Sometimes Mommie Gray was not in costume for those occasions, and that was the case when this photograph was taken. Standing in front of the car on the far right, she is wearing a very stylish hat and a fur coat.

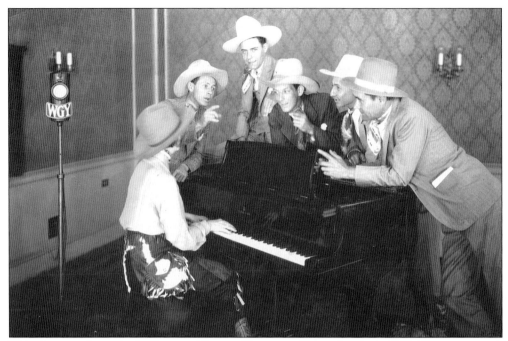

This photograph was in the *Scranton Times*, of Scranton, Pennsylvania, in 1931. The newspaper's caption under the photograph provided the information that "Gray and his entourage are known to millions of radio fans through their broadcasting efforts from 52 of the leading radio stations of the country and the Columbia network."

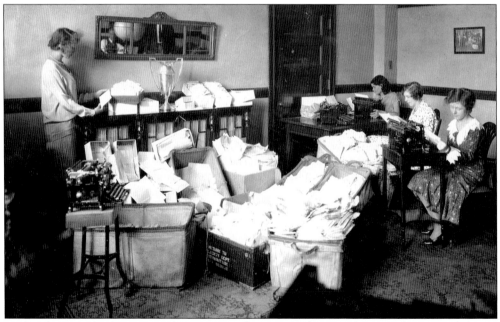

In this photograph, the WGY radio station mail room in Schenectady is overflowing with letters from fans of the Oklahoma Cowboy Band. From the band's very beginning, when it played over KFRU in Bristow in 1925, the enthusiastic response of listeners was an important factor leading to the band's success.

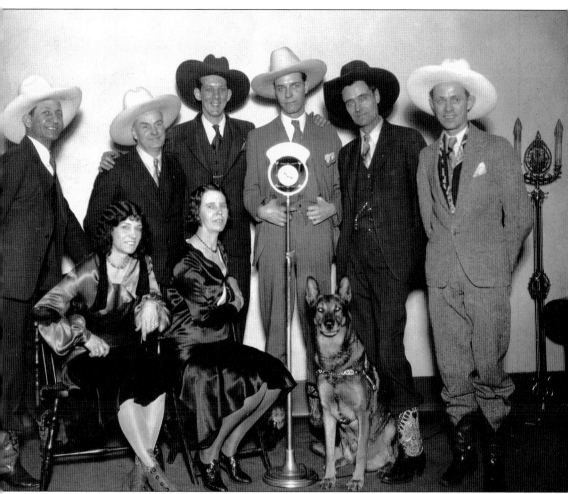

The *Scranton Times* owned radio station WQAN. In February 1931, the newspaper printed this photograph under the heading "WQAN Studio Picture of Oklahomans." Seen here are, from left to right, (first row) May Blossom, Mommie Gray, and Rex; (second row) Chief Sanders, Billy Knox, Wade Allen, Owen Gray, Otto, and Lee Allen. Knox was an occasional member of the band, who was also at times a sharpshooter with the band's stage show. Blossom does not appear with the band in any other photographs, and her relation to the band is not clear.

The partnership of Otto and Mommie Gray was central to the success of the Oklahoma Cowboy Band. Born Florence Opal Powell in Kansas, Mommie was one of 12 children. She moved with her family to Payne County, Oklahoma Territory, and met Otto at a dance. Early in their marriage they moved to Wyoming, where Otto was a cowboy, and she was a cook. They both honed their roping skills and appeared at county fairs and rodeos. When they returned to Payne County, they continued to perform rope tricks at public events. They had one child, Owen, who was born in 1908. By 1925, when Billy McGinty's Cowboy Band was becoming hugely successful, Mommie was ready for another challenge. As a part of the Oklahoma Cowboy Band, she sang the sad songs that were a part of her heritage. In all of the newspaper stories and other literature related to the band, she was always called "Mommie," or occasionally Mrs. Otto Gray. She seemed content to be known only as Mommie, and she was one of the first women in the nation to sing on stage and over the air with a western band.

Four

COWBOYS AND INDIANS

Claude Purvis, who was born in 1910, played with the Oklahoma Cowboy Band on vaudeville around 1928 and 1929. He was also known as "Doc" or "Boots" Purvis, and he embodied the spirit of the early Oklahoma Cowboy Band. Purvis formed the Oklahoma Indian Band sometime after he toured with Otto Gray and His Oklahoma Cowboys and before he joined Ken Hackley and His Oklahoma Cowboys. In 1932, Purvis began playing for Hackley, who led a band that was very obviously patterned after Otto Gray and His Oklahoma Cowboys, right down to the lady roper and the barking dog. However, Purvis was not happy with Hackley's band, and he stayed with it for only a few months. Since Purvis was from Kaw City, near the Osage reservation, and was one-fourth Osage himself, he was able to recruit members for an Indian band. In forming the Oklahoma Indian Band, he used the show business elements that he learned from Otto Gray: a special car to travel in and call attention to the band, professional publicity photographs to be used in newspapers and flyers, and costumes to give the band its own unique appearance. Also the band was a string band, just like the band led by Otto Gray. Gray's band even had a Native American performer, Chief Sanders, who played the violin in the Oklahoma Cowboy Band and was part Cherokee. R. N. Purvis, the son of Doc Purvis, said the Oklahoma Indian Band dispersed after one of its representatives stole the band's money and left them stranded. That experience, along with his unhappy days with Ken Hackley, may have convinced Doc Purvis that show business was not for him, and in 1938, the handsome young cowboy went to work for the Santa Fe Railroad.

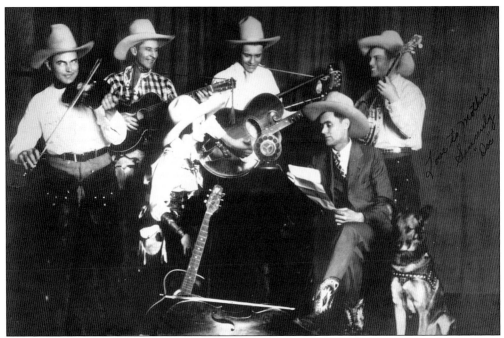

Boots Purvis, as he was called by Otto Gray, played with Otto Gray and His Oklahoma Cowboys during some of their busiest years on vaudeville. Shown in this photograph are, from left to right, Rube Tronson, Josh Fields, Mommie Gray, Owen Gray, Otto, and Purvis. The writing on the photograph says, "Love to Mother, Sincerely, Doc." (Courtesy R. N. Purvis.)

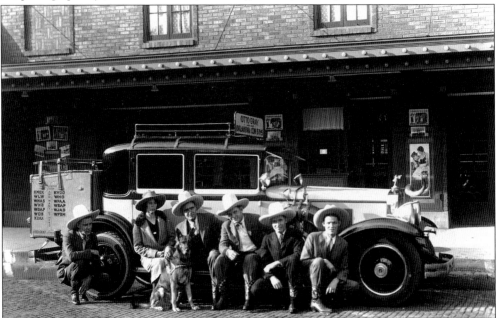

Purvis appeared in many of the Oklahoma Cowboy Band's publicity photographs. The band's custom-built car frequently served as a backdrop for such photographs. From left to right are Owen, Mommie, Otto, Purvis, Tronson, and unidentified. The canine member of the band, Rex, is sitting in front of Mommie and Otto.

In September 1932, Purvis joined Ken Hackley and his Oklahoma Cowboy Band. Otto Gray's lawyers had warned Hackley, whose advertisements were almost identical in appearance to Otto's, to cease copying Otto's act, but Hackley's band continued to perform as the Oklahoma Cowboys. Purvis stayed with Ken Hackley's band for just four months. He wrote to his sweetheart in Newkirk, "The boss has a funny idea and nobody knows why. He won't give us the route where we will be a week ahead so that makes us about 2 days late gitting our mail he's nuts . . . and is he tough on the boys. I don't think I'll stay to long with him." (Courtesy R. N. Purvis.)

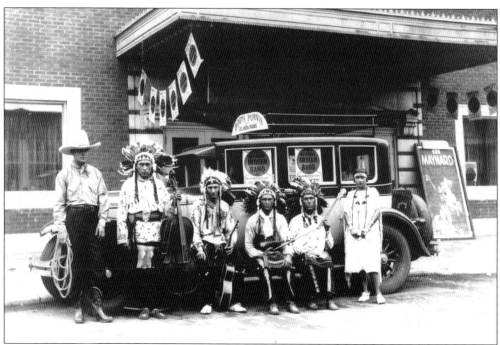

The Oklahoma Indian Band is shown in front of the band's car. Doc Purvis is on the far left. The woman in Native American dress on the far right is Geneva Bellmard. The other band members are unidentified. The automobile was used to advertise the Oklahoma Indian Band, just as Otto Gray used automobiles to advertise the Oklahoma Cowboy Band. (Courtesy R. N. Purvis.)

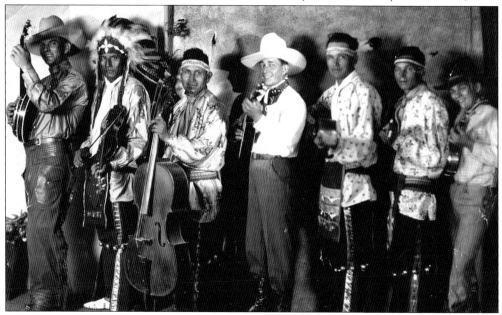

Doc Purvis is on the far left, but the rest of those pictured are unidentified. These entertainers are from the very early days of country and western music, and this branch of the family tree shows the influence of Wild West shows on the development of country and western music. (Courtesy R. N. Purvis.)

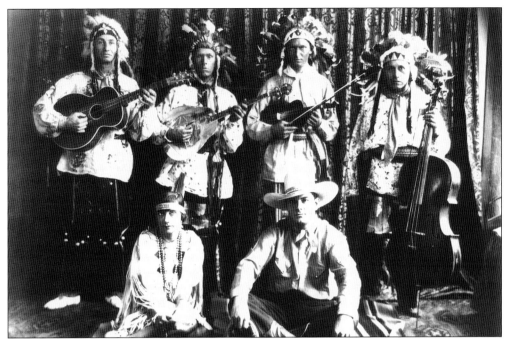

The Native American members of the band played stringed instruments, as did Purvis, who played the mandolin, banjo, and guitar. The woman seated next to Purvis is Geneva Bellmard, the band's female singer. The Oklahoma Indian Band broke up after its representative in one town ran off with the band's money. (Courtesy R. N. Purvis.)

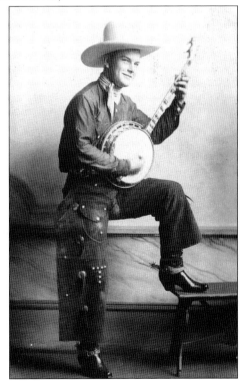

When Purvis joined the Oklahoma Cowboy Band, he was a featured singer and undoubtedly one of the first cowboys to sing solos over radio and on vaudeville. This photograph of him was taken when he was the leader of the Oklahoma Indian Band. (Courtesy R. N. Purvis.)

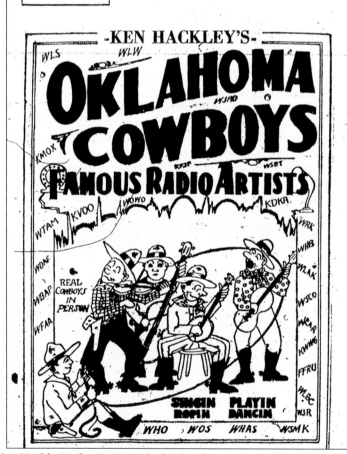

Ken Hackley's advertisement for his band looks very much like the advertisements for Otto Gray and His Oklahoma Cowboys. Hackley, who was from Indiana, appears to be taking credit for much of Otto Gray's success, assuming that most people would not check on the accuracy of his claims. Hackley even had a dog who was called "the bark of the air." When Doc Purvis was traveling with Ken Hackley's band in 1932, they were on what was called the "little Orpheum circuit," which included Minnesota. This advertisement appeared in the *St. Cloud Daily Times* on September 19, 1932. (Courtesy R. N. Purvis.)

Five

COWBOYS ON VAUDEVILLE

From the latter part of the 19th century until the 1930s, vaudeville was one of the country's primary sources of entertainment. The term *vaudeville* is of French origin and the original meaning is unclear, but in America vaudeville was synonymous with show business. Vaudeville theaters presented a series of short acts for the entertainment of the audience. Singers, dancers, actors, musicians, comedians, and trained animal acts all appeared on vaudeville.

The Oklahoma Cowboy Band began its career just as vaudeville was facing major changes. In 1925, phonographs and radio were on the verge of becoming accessible across the country. In 1927, *The Jazz Singer* became the first "talkie," and before long, all movies had sound. By the early 1930s, vaudeville was being challenged by new forms of entertainment—and by a worsening economy. The country was in the depths of the Depression.

When the cowboy musicians made their first trip to Kansas City in early 1926, the reception given to the cowboys encouraged them to continue. As they traveled farther to the east and northeast, the band became increasingly successful, both on the radio and on vaudeville. Audiences wrote thousands of letters to the radio stations where the cowboys played. Comic songs like "Plant a Watermelon on My Grave" and "The Terrible Marriage," could make the audience laugh and forget about their own problems, while Mommie Gray's sad songs, like "Drunkard's Lone Child," perhaps reminded listeners that others were in worse situations than they were. "The Cowboy's Lament" took listeners back to the old West and the dangers faced by the brave young cowboys.

In 1930, the *Indianapolis Times* carried an article with the headline "Cowboys Capture Fancy of Audience." The reporter wrote, "The success of Otto Gray and his gang over the radio is being duplicated upon the variety stage. I am frank when I tell you that I never have seen an audience in a vaudeville theater get so worked up as the first audience I saw at the Lyric yesterday. Every seat was taken and people were standing up." Many other clippings in the band's scrapbooks contain similar reports.

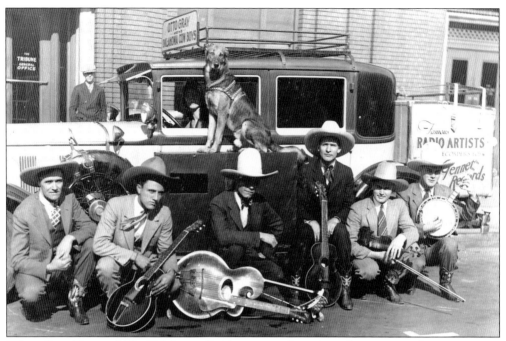

When Otto Gray and His Oklahoma Cowboys arrived in town, their means of transportation brought them immediate attention. This publicity photograph of the band with their "specially built Cadillac" was taken around 1928 or 1929. Seen are, from left to right, Otto Gray, unidentified, Owen Gray, Chief Sanders, Rube Tronson, and Doc Purvis. Rex is sitting above the cowboys.

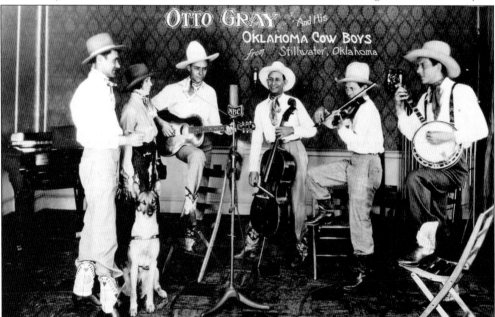

Otto rarely missed a chance to advertise Stillwater as the home of Otto Gray and His Oklahoma Cowboys. This postcard was distributed widely, thus giving the band and the town of Stillwater publicity and creating more awareness of both. In this image are, from left to right, Otto, Mommie, Owen, Chief Sanders, Lee Allen, and Wade Allen. Rex, the dog, is seated in front of Otto.

Although music was the primary reason for the Oklahoma Cowboy Band's existence, comedy was a big part of the band's vaudeville act. In some cases the band's monkey, dog, or miniature horse took part in a comedy skit, and sometimes the cowboys engaged in some verbal give and take. Perhaps the most unexpected transformation took place when Owen played the role of Zeb the Uke Buster. With shaggy hair and a blacked out tooth, Owen changed his appearance dramatically, making him a versatile member of the band.

This configuration of players was part of a standard comedy act for Otto Gray and His Oklahoma Cowboys. The band members shown are, from left to right, Rube Tronson, Owen Gray, Josh Fields, and Doc Purvis. A newspaper clipping with a photograph of the mixed-up quartet says, "Easy? Well, just try it some time."

Benjamin "Whitey" Ford, later known as the "Duke of Paducah," was a part of the Oklahoma Cowboy Band for a period of time around 1927 or 1928. Around 1932, he returned to the band and developed an act with Owen in which both played comic roles. The duo took the act and went out on their own for a while, but apparently the act did not catch on. Later Ford became quite successful as the Duke of Paducah on the Grand Ole Opry.

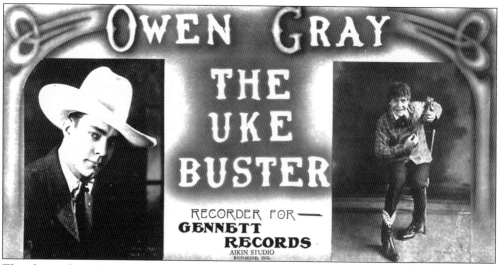

This design from the Aikin Studio, of Richmond, Indiana, identifies Owen Gray as "the Uke Buster." It also indicates that he recorded for Gennett, which was just one of several recording studios that made records for the Oklahoma Cowboy Band. Owen was just over 20 years of age when this design was created. (Courtesy Vicki George.)

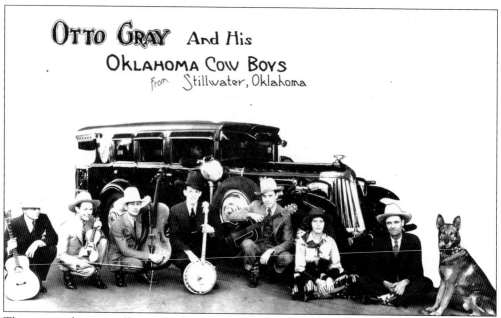

This postcard is very effective in the way it uses the image of the car and the band members. The man on the far left is unidentified. The rest of the cowboys are, from left to right, Lee Allen, Chief Sanders, Wade Allen, Owen, Mommie Gray, Otto Gray, and Rex. The card includes the information that the band is from Stillwater, Oklahoma—something Otto wanted everyone to know.

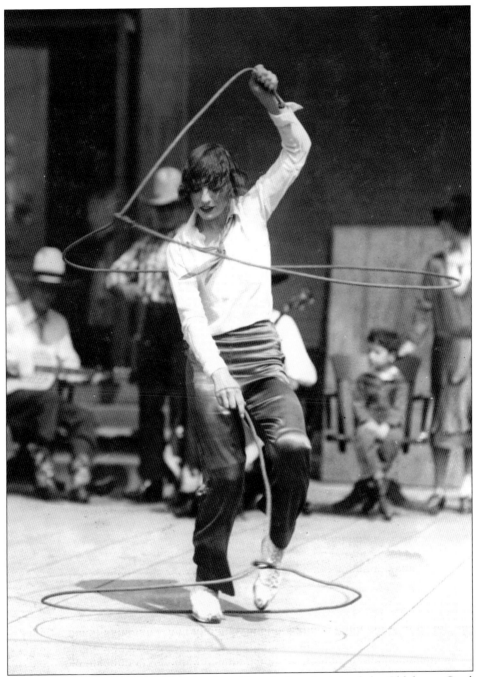

Mommie's skills as a trick roper were developed long before she joined the Oklahoma Cowboy Band. She and Otto performed before audiences at county fairs and other events in both Oklahoma and Wyoming. Her ability to perform on stage as a singer and a trick roper made her well suited for vaudeville. Another benefit Mommie may have provided for the band was to create a stabilizing effect for the musicians. Owen was only 18 when he started traveling with the band, and Doc Purvis was 17 or 18 when he began touring with the band. In a sense, these cowboys were still boys when they started out.

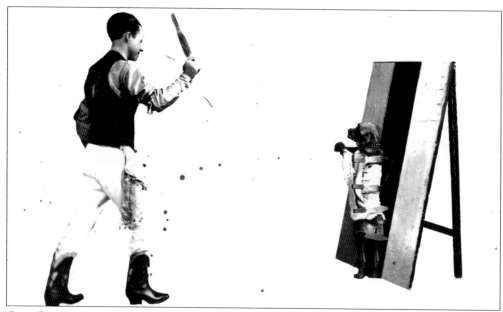

Otto Gray's entrepreneurial instincts resulted in various nonmusical acts being added to the band's stage show. Here, sometime in 1929, Jack Edwards is shown exhibiting his knife-throwing skills with his dog, Atlas. This act is reminiscent of the "death-defying" acts of the circus and Wild West shows.

Atlas the dog was not the only member of Edwards' knife-throwing act. It was reported once that during a rehearsal Ruby Edwards, Jack's wife, was "slashed in the left arm." The arm was bandaged, and "Mrs. Edwards went on for the afternoon and night show." Gray's troupe followed the show business axiom of "the show must go on." (Courtesy Vicki George.)

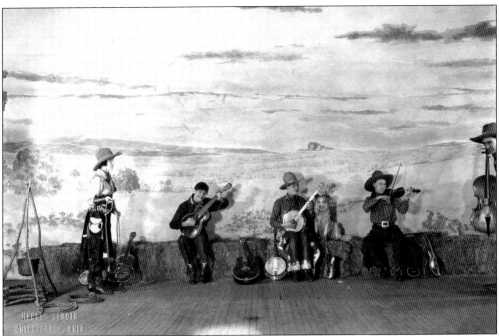

This scene from the band's vaudeville act shows a variety of string instruments. According to one contract, all the theater had to provide for the act was six bales of hay. From left to right are Mommie Gray, Owen Gray, two unidentified band members, and Otto. This photograph was probably taken early in the band's vaudeville career, since the dog in the scene is Duke, the predecessor to Rex.

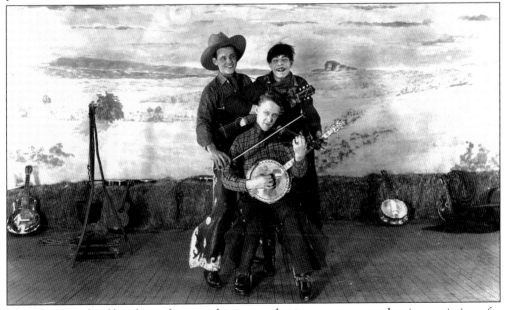

This photograph of band members combining to play instruments together is a variation of a novelty act used frequently by the cowboys. Standing on the left is Fred Wilson. Owen, who is on the right, is dressed as the character Zeb, who was also known as the Uke Buster. The man in front is unidentified.

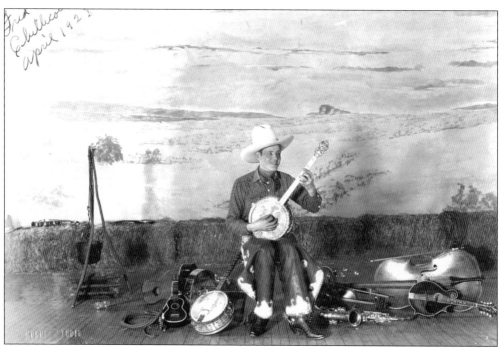

This photograph shows Oklahoma Cowboy Band member Fred Wilson with a variety of string instruments—and what appears to be a brass instrument near his foot. Most of the band members were versatile musicians who played several different string instruments. (Courtesy Vicki George.)

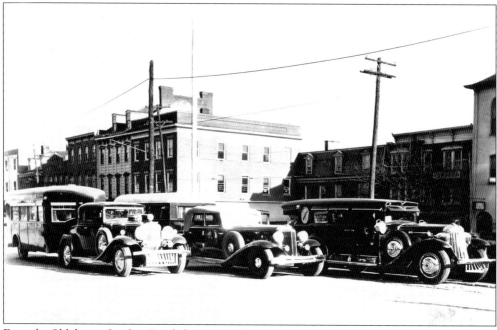

From the Oklahoma Cowboy Band's beginning, the automobile was a major part of the band's image. As the band became more successful, Otto Gray added cars to his fleet. When the custom-built cars arrived in town, they were as much a part of the entertainment as the band itself.

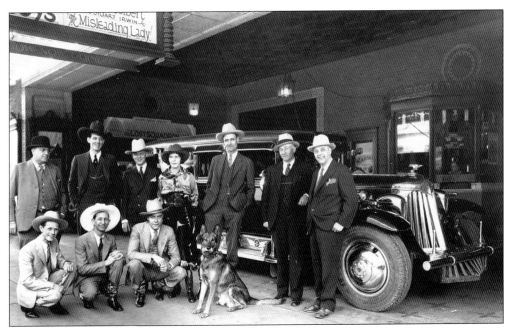

Otto Gray and His Oklahoma Cowboys were on the Butterfield Circuit in Michigan in 1933. Their car cost $20,000 and was equipped and wired for sound reproduction. It also had a radio receiver and transmitter. Standing are, from left to right, unidentified, Wade Allen, Benjamin "Whitey" Ford, Mommie Gray, and Otto. The two men on the right are unidentified. Sitting are, from left to right, Lee Allen, Chief Sanders, and Owen Gray.

This snapshot provides a glimpse of Otto and Mommie off stage. A reporter interviewed Mommie for the *Buffalo Evening News*, and the resulting story offers some insight into Mommie's feelings about her marriage. "Successful marriage," she said, "comes of meeting one another half way." Yet later in the interview Mommie added, "It's a man's world, in spite of all the talk of women's freedom." (Courtesy Vicki George.)

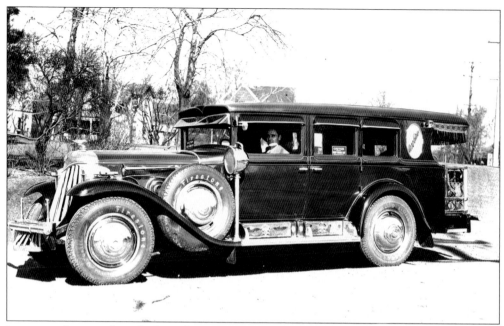

In a rare photograph with Otto Gray alone in one of his cars, not even his dog, Rex, is in this picture. This view of the car shows that it has Firestone tires. Apparently Gray had an arrangement with Firestone to endorse his tires. An article appeared in 1932 describing Gray's visit to a Firestone dealer in Fort Wayne, Indiana. (Courtesy Vicki George.)

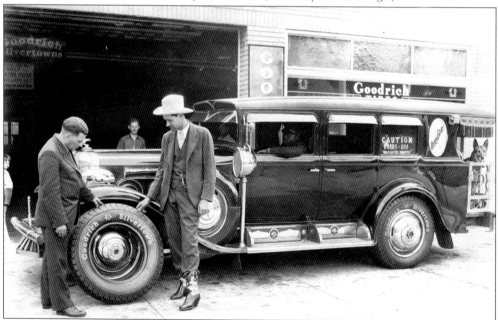

In 1933, Gray provided an endorsement for a car dealer in Lima, Ohio. The advertisement declared, "Otto Gray Demands Better Service Than Ordinary from an Automobile So He Drives a Cadillac." Gray also took advantage of the opportunity to endorse the tires used on his fleet of cars by appearing in a newspaper advertisement for Goodrich Safety Silvertown tires. (Courtesy Vicki George.)

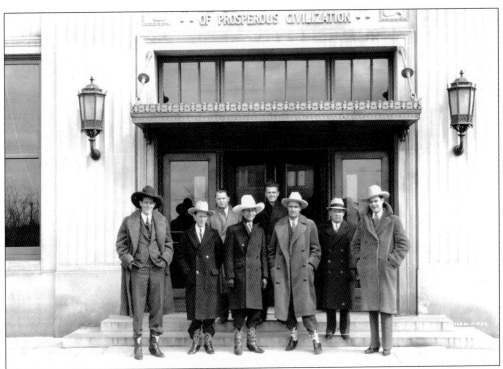

Here Owen Gray, on the far right, has changed from being the Uke Buster to dressing like a successful businessman. His father, Otto (third from the right), used his skills in business as the band's manager, but Owen, who was 18 when he started playing with the band, never had to prove himself on his own. (Courtesy Vicki George.)

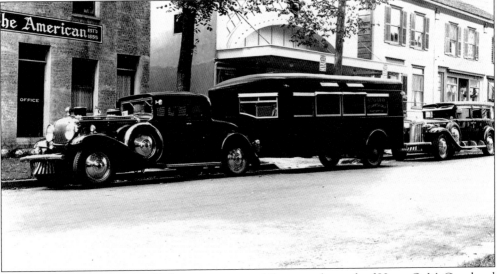

The Oklahoma Cowboy Band's distinctive automobiles were the work of Harry O. McGee, head of the H. O. McGee Manufacturing Company of Indianapolis. In 1925, McGee built "the world's first transcontinental trackless highway train," an automobile that looked like a train engine pulling a railroad car. In 1936, the Oklahoma Cowboy Band made its final tour, and after that, the attention-getting fleet of cars was no longer a part of show business. (Courtesy Vicki George.)

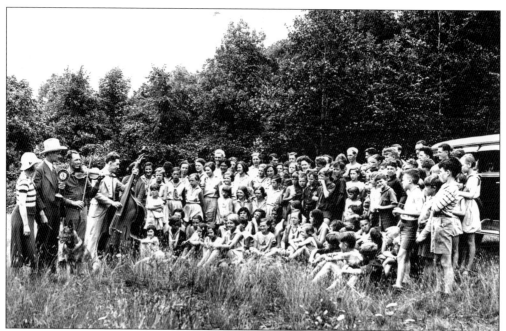

Otto Gray and His Oklahoma Cowboys continued to donate their time to good causes. Around 1932, the cowboys visited the Trinity Institute Camp near Albany, New York. The band, on the far left, consisted of Mommie and Otto Gray, Lee Allen, Ralph Gerard, and Rex. Otto said that Owen and the other cowboys were supposed to be there but probably got their directions mixed up.

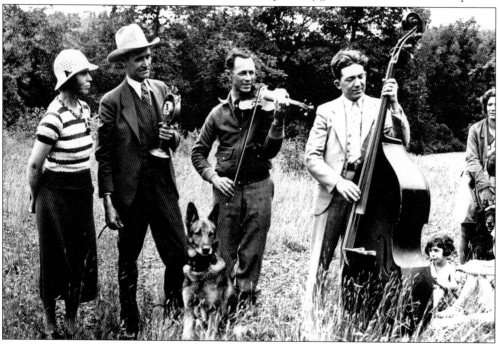

This is one of the few times that Mommie is seen in regular street clothes. Lee Allen, too, is dressed casually. Ralph Gerard, on the right, is probably a substitute brought in for the occasion. Otto complained about not having any guitars for the band.

Otto is shown in a close-up with some of the children at the Trinity Institute Camp. Two of the girls, identified as Evelyn Saulsbury, on the left, and Dorothy Mary Bennett, are "broadcasting." Rex is in his usual place in front of the camera.

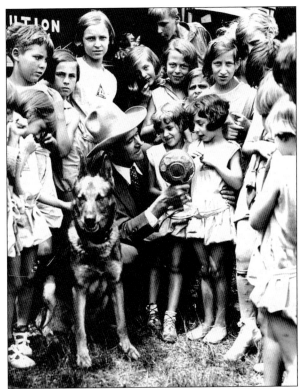

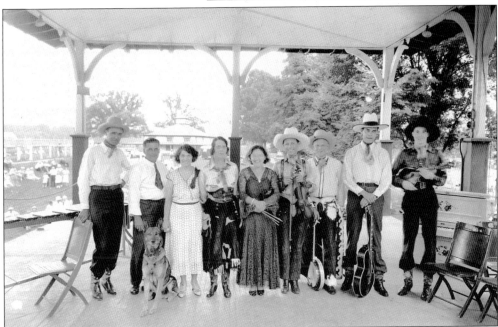

In August 1932, Otto Gray and His Oklahoma Cowboys played before a huge crowd at the En-Joie Health Park in New York. The park was owned by the Endicott Johnson Shoe Company, a large corporation with factories in Binghamton, Johnson City, and Endicott. The *Endicott Johnson Workers Daily Page* reported that the cowboys drew the largest crowd of the season.

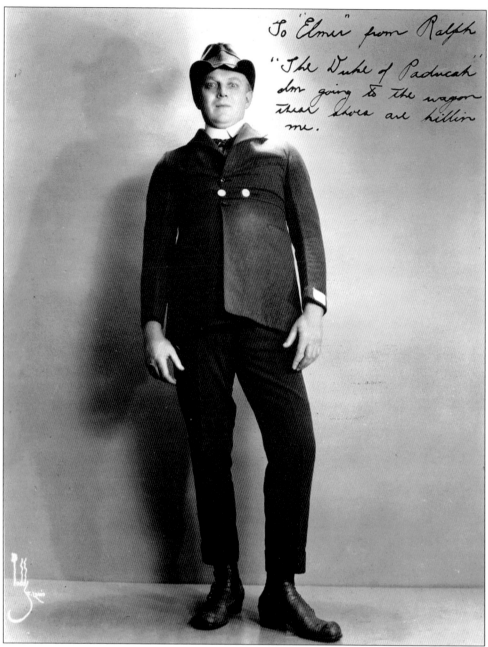

To "Elmer" from Ralph
"The Duke of Paducah"
Im going to the wagon
these shoes are killin
me.

Benjamin "Whitey" Ford, who was a musician with the Oklahoma Cowboy Band in the late 1920s, joined the band again in 1932 and 1933. He was with Otto Gray and his family when the plane they were in crash landed in a pasture near Geneva, New York. During his second stint with the cowboy band, he honed his comedy skills and developed his act as the Duke of Paducah. He performed with Owen Gray, using the stage name "Elmer," while Owen was "Ralph." The "hillbilly duo," as they were called, also appeared at the Roxy in New York City. Despite some initial positive reviews, their act apparently did not catch on, and in the 1940s, Ford went on to star on the Grand Ole Opry in Nashville. He died in 1986 and was elected to the Country Music Hall of Fame in the same year.

Otto maintained good relations with those who worked for him long after they left the band. Reba Bennett Harvey, daughter of early band member Johnny Bennett, remembers going with her father to see Otto when they were in Stillwater. Many years after this photograph was taken, Ford visited Otto at his home in Stillwater.

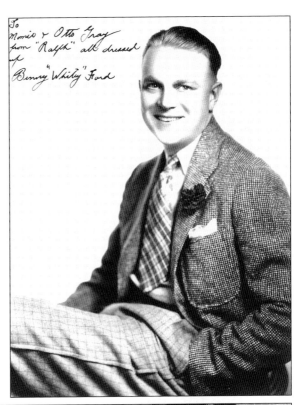

To
Momie & Otto Gray
from "Ralph" all dressed up
Benny "Whitey" Ford

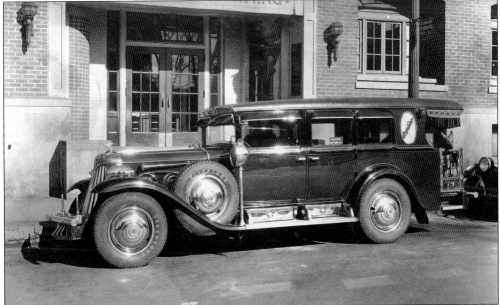

A clipping in the band's scrapbook says, "Cowboys Here In Fancy Cars." The article begins, "Otto Gray, owner and originator of one of the greatest attractions of radio and stage, arrived Sunday about noon with his entire organization of Oklahoma cowboys." In 1934, the band had been traveling for eight years. The fancy car, although still impressive, seems empty in this photograph although Rex is on the observation deck. (Courtesy Vicki George.)

Law Offices

Fitelson, Lerman and Mayers
Seventy West Fortieth Street
New York

H. WILLIAM FITELSON
HAROLD A. LERMAN
BERTRAM A. MAYERS

I. JACK LONDON

July 10th, 1931

Mr. Otto Gray,
c/o Station W-G-Y,
Schenectady, New York.

Re: Gray v. Tommy Tompkins

Dear Mr. Gray:

We have written to Tommy Tompkins demanding an immediate cessation of all further use of the words "OKLAHOMA COWPUNCHERS". We have also advised Mr. Tompkins that unless he immediately ceases such use and mis-appropriation of your property rights, we will proceed at once to apply to the Courts for an injunction restraining and enjoining him from so doing and also commence an action against him for damages.

We have also written to the Strong Theatre enclosing a copy of the aforesaid letter written to Mr. Tompkins and have asked the theatre to inform us of the future booking dates and places of Mr. Tompkins.

We are now awaiting his reply and will be pleased to advise you of further developments.

Yours very truly,

FITELSON, LERMAN and MAYERS

By Bertram A. Mayers

HWF:P
Copy to Stillwater
Okla.

In the early 1930s, more acts were calling themselves "Oklahoma cowboys." Otto Gray had his spokesman issue a warning to radio stations that "throughout the country various imposters have recently and are presently obtaining bookings in vaudeville and on the radio relying on fraudulent misrepresentations contained in their billing and publicity that they are 'Oklahoma Cowboys.'" When that did not work, Gray had his lawyers file lawsuits against the offending parties, including Tommy Tompkins, Dan Sherman, and Kenneth Hackley.

Gray worked hard to establish Otto Gray and His Oklahoma Cowboys on radio and vaudeville. In 1932, *Billboard* printed a story about "name abuse" in show business, citing Cab Calloway and Otto Gray and His Oklahoma Cowboys as the two most frequently imitated acts on vaudeville and radio. After Gray's lawyers filed a suit against Hackley in 1932, a United States district court issued an order preventing Hackley from using Gray's copyrighted material, including the term "Oklahoma Cowboys."

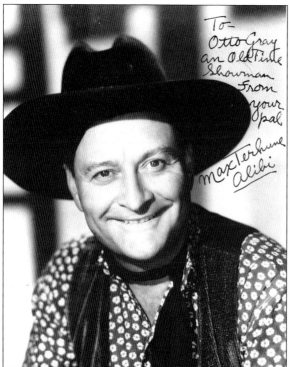

Max Terhune was a talented vaudevillian whose specialty was ventriloquism. In 1936, he moved on to Hollywood and the movies, many of them Westerns. After leaving movies, he continued to appear on television shows. While he was never a member of Otto Gray's troupe, the two vaudeville performers shared similar experiences in show business. (Courtesy Vicki George.)

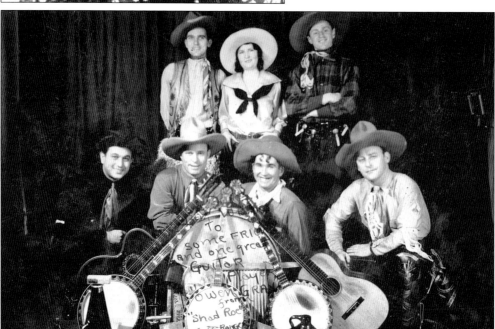

The Texas Rangers followed a path blazed by the Oklahoma Cowboy Band. Otto Gray and His Oklahoma Cowboys were the first western band on vaudeville and radio, and the Oklahoma musicians were now being joined by many other western bands. When it began touring as Billy McGinty's Cowboy Band in 1925, the band was unique. By 1932, it was one of many cowboy bands on vaudeville and throughout America. (Courtesy Vickie George.)

Otto Gray and His Oklahoma Cowboys appeared on the cover of *Billboard* magazine on June 6, 1931. That was the first time that a cowboy band appeared on the front of the country's leading show business magazine. In 1934, this photograph of Gray was on the cover of *Billboard*, showing that Otto Gray and His Oklahoma Cowboys were still a significant part of the entertainment industry. Pennsylvania's *Lewistown Sentinel* began a story about the band with, "N.B.C. Stars Coming Here." The *Lewistown Sentinel* continued, "Probably the most imitated of all radio and stage attractions are the Oklahoma Cowboys. But there is one attraction that is known to every man, woman and child that ever listened to a radio . . . and that is Otto Gray and his world famous Oklahoma Cowboys and Rodeo Rubes."

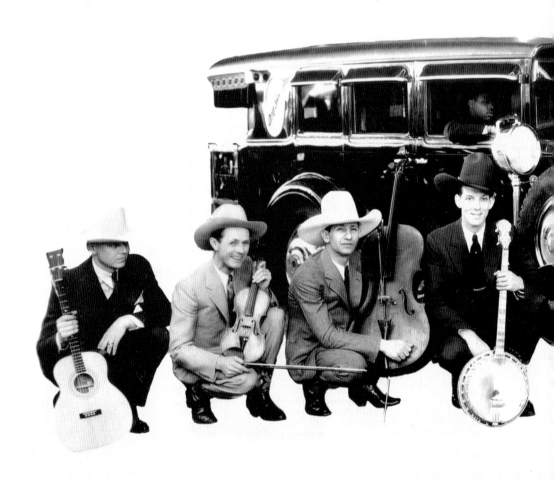

The Oklahoma Cowboy Band's custom-built cars left an indelible impression on those who saw them. The cars became as much a part of the band's identity as their cowboy hats, boots, banjos, and fiddles were. Otto Gray found success by combining old themes with new technologies, and for a decade, he found enthusiastic audiences eager to join in the fun. In this photograph,

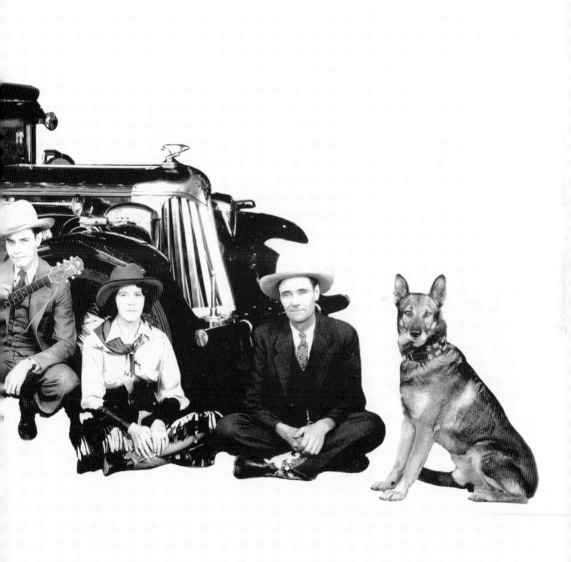

the first cowboy on the left is unidentified. The others are, from left to right, Lee Allen, Chief Sanders, Wade Allen, Owen Gray, Mommie Gray, and Otto. Rex, the wonder dog, is sitting near Otto, on the far right.

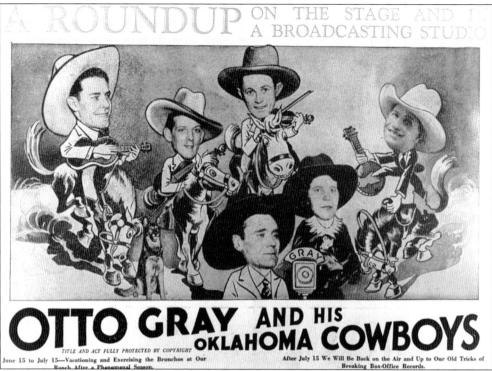

This advertisement for the band promoted both radio and stage appearances. It also served to let the public know that from June 15 to July 15, the cowboys would be "vacationing and exercising the bronchos at our ranch after a phenomenal season." In front are Otto and Mommie Gray, and from left to right in back are Owen Gray, Wade Allen, Lee Allen, and Chief Sanders.

Among the cowboy band's collection of photographs is this glamorous portrait of a woman named Margaret. Margaret may have been a close friend of someone in the Oklahoma Cowboy Band, or she may have been just an acquaintance. She wrote on the photograph, "What is there I can say anyway? Sincerely, Margaret." This cryptic message only adds to the mystery. (Courtesy Vicki George.)

Owen played a prominent role in the history of the Oklahoma Cowboy Band. He was six feet and four inches tall, and with his cowboy boots on, he must have been an imposing presence both on and off stage. After the end of his vaudeville career, though, he seemed to have a difficult time finding his niche in life. He died in Stillwater at the age of 39. (Courtesy Vicki George.)

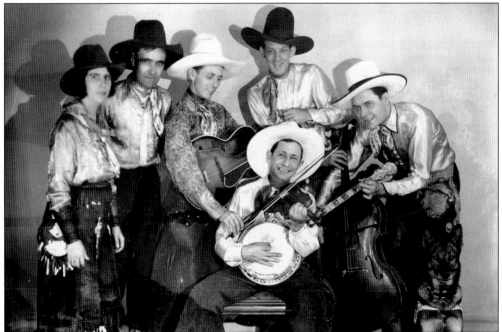

This photograph of Otto Gray and His Oklahoma Cowboys features dramatic shadows, with the musicians forming a "mixed-up" version of the band. This photograph differs from others showing similar scenes, in that Otto and Mommie are standing beside the band. Seen here are, from left to right, Mommie, Otto, Lee, Wade, and Owen. Seated in front is Chief Sanders. And of course, Rex takes his usual place in front of the band.

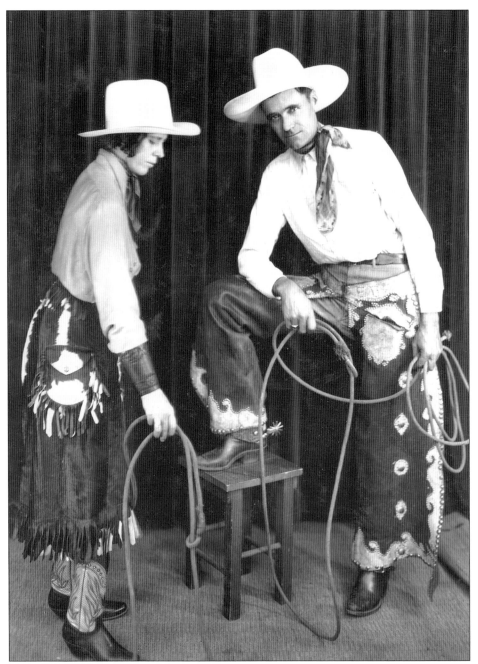

Otto Gray married Florence Powell, known only as Mommie to the public, in 1906, the year before Oklahoma became a state. They began a remarkable journey 20 years later, taking their only child, Owen, with them. To their vaudeville audiences, they represented the West and a free, unfettered way of life. For Florence and Otto though, vaudeville was the key to wealth exceeding anything possible on the small Oklahoma ranch where they began their married life. As for Otto's contribution to the development of country music and western bands in America, western writer Glenn Shirley wrote in 1959, "Otto Gray, who put the first all-string cowboy band on stage, radio and records, is the acknowledged 'daddy of 'em all.'"

Six

BACK ON THE RANCH

By the mid-1930s, vaudeville was facing tough times. In an effort to stay afloat, management added more performances to the schedules, but that did not help. For several years, theaters showed movies along with the vaudeville acts, but that simply served as a transition to showing movies full time. By 1936, the Oklahoma Cowboy Band's travels were over. Otto Gray reportedly said that he was "turning it over to Bob Wills," the highly successful bandleader who introduced western swing music on KVOO in Tulsa. While Gray had earned large sums of money on vaudeville, he had also spent large sums on custom-built cars and traveling expenses. Still he and Florence had enough resources for a comfortable retirement, although Otto was not quite ready to retire yet. He worked in real estate and raised miniature cattle. The call of show business was hard to resist, and in 1939, he took some of his miniature cattle to several fairs in the Midwest, with the Gus Sun booking company handling the arrangements. Owen served in the army during World War II. He died in 1947, and Florence died in 1952. Three years later, Otto married his second wife, Elsie, and they settled down in his home on the southern edge of Stillwater. In his later years, Billy McGinty, the leader of Billy McGinty's Cowboy Band, served as the president for life of the National Rough Riders Association. He met each year with the diminishing number of Rough Riders at Las Vegas, New Mexico. McGinty died in 1961. In 1988, a plaque honoring McGinty was placed in the Ripley Post Office, and in 2000, he was named to the Hall of Great Westerners by the National Cowboy and Western Heritage Museum. Otto died in 1967, with his career as the leader of the nation's first commercially successful western band almost forgotten.

The Sac and Fox Nation is still a part of life along the Cimarron River. Jim Thorpe, one of the greatest athletes of the 20th century, was Sac and Fox, and during the 1920s, he lived in Yale in eastern Payne County. This recent photograph, taken by C. R. Cowen, shows Jaque White Buffalo, Kiowa, and Ronnie G. Harris Jr., Sac and Fox, at a powwow at the University of Oklahoma at Norman. (Courtesy Research Division of the Oklahoma Historical Society.)

Billy McGinty remained a legendary figure during his lifetime, and Ripley was proud to be the home of the famous cowboy. During his later years, he was president of the Rough Riders Association and traveled to Las Vegas, New Mexico, to attend the annual meetings of the Rough Riders.

Billy McGinty and Otto Gray were lifelong friends who had shared some amazing adventures. They were both genuine cowboys who had many experiences in common. Billy McGinty's Cowboy Band started out almost as a lark, a spur-of-the-moment decision to perform for the new medium of radio. In 1925, no one really knew what to expect. When Gray began touring with the band, there were no other cowboy bands on vaudeville, and everything was new and exciting. By the time he quit, in 1936, there were western bands everywhere. (Courtesy Mary Ruth Koutz.)

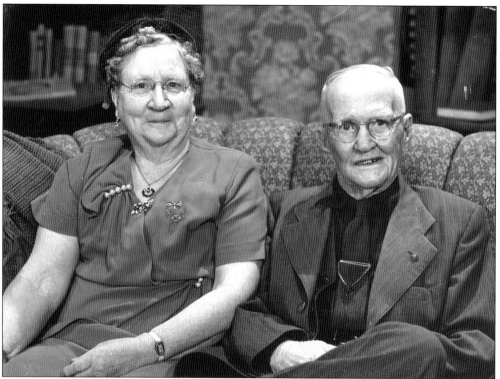

Billy McGinty and his wife, Mollie, were respected and admired by many. Both had strong ties to the Ingalls area, where their families had homesteaded in 1889, and their years in Ripley brought them many friends over the years. McGinty's adventures with a cowboy band were just a part of his amazing life.

This photograph, taken in 1958, shows old cowboys Lon Case, Gib Shaw, and Billy McGinty in front of Ingalls's monument to the lawmen slain in the shoot-out of 1893. In the mid-1970s, an oil company truck backed into the monument and destroyed it. In the early 1990s, a new monument was built to replace the one destroyed earlier.

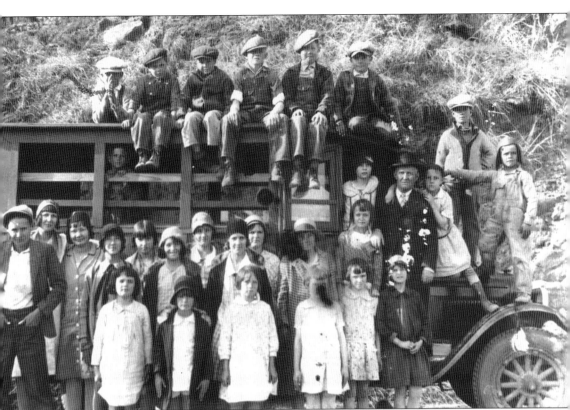

At one time, Billy McGinty drove a bus for the Ripley school. His occupations over his lifetime included, but were not limited to, cowboy, soldier, Wild West Show performer, rancher, postmaster, Ford car dealer, cowboy band leader, and bus driver. For many, he also served as a symbol of the old West and what was good and heroic about the pioneers of that era.

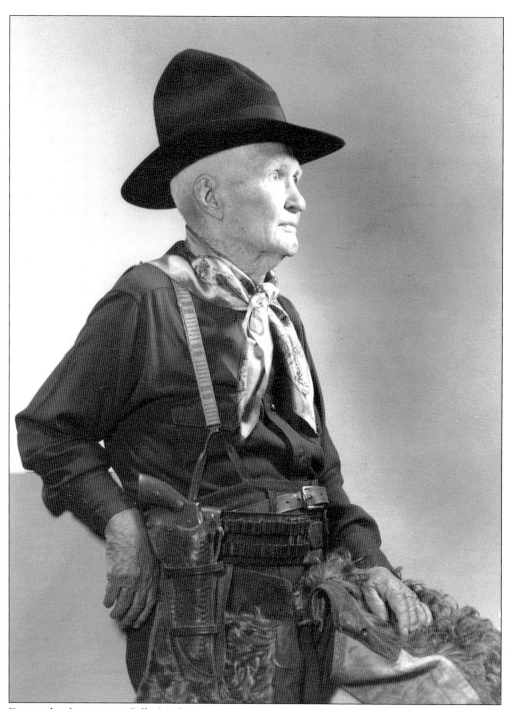

During his later years, Billy McGinty was recognized for his service as a Rough Rider in the Spanish-American War and for his many other achievements as a cowboy and broncobuster. In the 1950s, he was a living reminder of the old West and the adventurous life of the cowboy. He was remembered too as the leader of Billy McGinty's Cowboy Band, the first western band to play over the radio.

McGinty, who was generous by nature, frequently shared his memories and his collections with the press and anyone else who was interested. With the help of local newspaperman Glenn Eyler, he wrote a history of his life as a cowboy called *The Old West*. It was published in 1937.

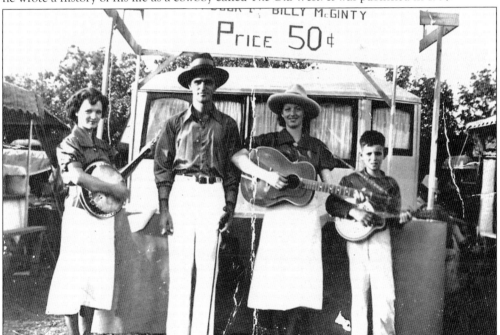

After the publication of McGinty's *The Old West* in 1937, a local group called the Westerners helped to promote sales of the book. Shown are, from left to right, Ripley residents Aletha Carothers Snyder, Dale Carothers, Dorothy Carothers, and Bob Carothers.

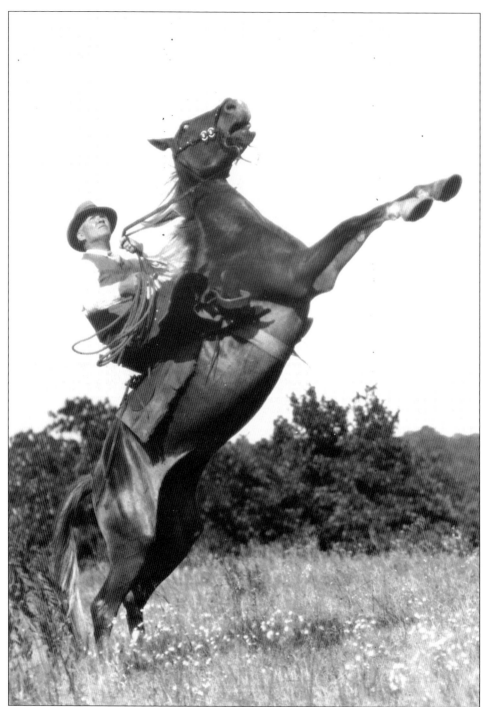

As a young cowboy, Billy McGinty was widely known for his ability to break a horse to ride. He began working as a cowboy when he was 14, and he quickly learned all the skills of a cowboy. He was a short man, reportedly only five feet and two inches tall, but he was tenacious when riding a horse. Theodore Roosevelt called him "little McGinty," but his courage and riding skills were enormous. Even when he was older, as in this photograph, he was a fearless rider.

McGinty's friends included people from all walks of life. He knew the famous humorist Will Rogers from the time both were working for Wild West shows in New York. Augusta Metcalfe, shown here with McGinty, was a western Oklahoma artist who was known for portraying the state's pioneer days.

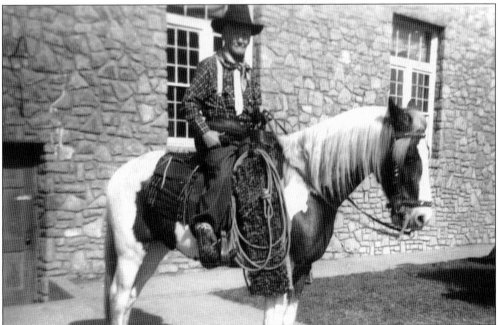

As he grew older, McGinty continued to ride. As Ripley's most famous citizen, he was known by almost everyone in the surrounding communities. He appeared in parades and at special events like old settlers reunions. In effect, he served as a living representative of the early days of Payne County's history.

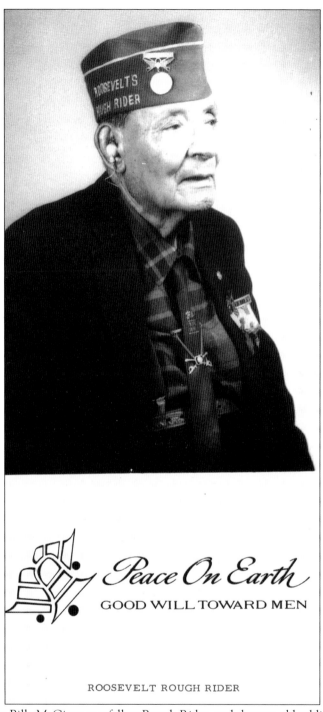

Peace On Earth

GOOD WILL TOWARD MEN

ROOSEVELT ROUGH RIDER

Frank Brito knew Billy McGinty as a fellow Rough Rider, and the two old soldiers kept in touch over the years. In the 1950s, the ranks of Theodore Roosevelt's Rough Riders were growing thin. McGinty was elected president for life of the National Association of Rough Riders and annually traveled to Las Vegas, New Mexico, to attend the organization's reunions. In 1973, Brito died at the age of 96, leaving one last surviving Rough Rider, Jesse Langdon, who died two years later.

This little roster is dedicated to the men who served with us in the war with Spain, 1898, and are now out in that great space where the comets spin, may their memory ever remain in our hearts.

National Association
ROOSEVELT'S ROUGH RIDERS
1st U. S. Volunteer Cavalry

Officers
1953-1954

WM. (Billy) McGINTY
President

JAMES T. BROWN
Sr. Vice President

DR. GEO. B. HAMNER, M.D.
Jr. Vice President

ROBERT W. DENNY
Secretary-Treasurer

DICK SHANAFELT
Assistant Secretary

CHAS. O. HOPPING
Chaplain

COL. M. L. CRIMMINS
Collector Historical
Reminiscense

Reunion Committee

JESSE D. LANGDON, Chairman
JAMES W. ARROTT, Asst Chairman
O. W. (Jack) McGINTY, Asst. Chairman

This page from the 1953–1954 agenda for the annual reunion of Roosevelt's Rough Riders includes the name of O. W. "Jack" McGinty. Jack, who was one of Billy's three sons, became involved with the Rough Riders organization through attending the meetings with his father. Years later, Jack liked to talk about the Rough Riders he had come to know at the reunions.

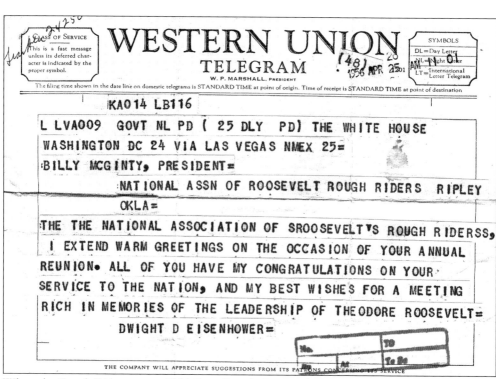

WESTERN UNION
TELEGRAM
W. P. MARSHALL, PRESIDENT

The filing time shown in the date line on domestic telegrams is STANDARD TIME at point of origin. Time of receipt is STANDARD TIME at point of destination

KA014 LB116

L LVA009 GOVT NL PD (25 DLY PD) THE WHITE HOUSE
WASHINGTON DC 24 VIA LAS VEGAS NMEX 25=

BILLY MCGINTY, PRESIDENT=

 NATIONAL ASSN OF ROOSEVELT ROUGH RIDERS RIPLEY
 OKLA=

THE THE NATIONAL ASSOCIATION OF SROOSEVELT'S ROUGH RIDERSS,
 I EXTEND WARM GREETINGS ON THE OCCASION OF YOUR ANNUAL
REUNION. ALL OF YOU HAVE MY CONGRATULATIONS ON YOUR
SERVICE TO THE NATION, AND MY BEST WISHES FOR A MEETING
RICH IN MEMORIES OF THE LEADERSHIP OF THEODORE ROOSEVELT=
 DWIGHT D EISENHOWER=

THE COMPANY WILL APPRECIATE SUGGESTIONS FROM ITS PATRONS CONCERNING ITS SERVICE

When the Rough Riders met in 1956, Pres. Dwight D. Eisenhower sent a congratulatory telegram to Billy McGinty, the president of the National Association of Rough Riders. President Eisenhower praised the Rough Riders for their service to their country in the Spanish-American War.

Otto Wayne "Jack" McGinty was employed in the oil industry. After he retired, he worked to save the heritage of the Ripley area, including that of Otto Gray and Billy McGinty, who were pioneers in America's country music history. He served as the first chairman of the board of trustees of the Washington Irving Trail and Museum, which is located on the homestead of Gray's family. (Courtesy Mary Ruth Koutz.)

Gray had a lifelong interest in livestock breeding. When he was the leader of the Oklahoma Cowboy Band, he raised miniature horses, as well as the ponies that were prizes in contests publicizing the band. In later years, he raised midget cattle, offering them for sale and exhibiting them at fairs in the Midwest.

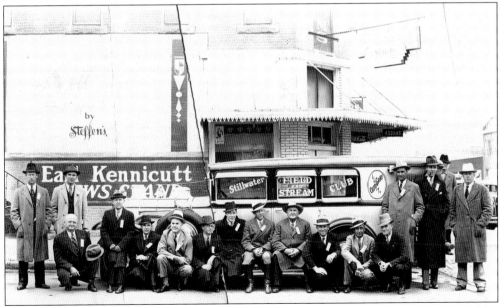

This undated—and damaged—photograph indicates that after vaudeville, Gray continued his interest in custom-built cars. It may be that this car was one of those that were used for the Oklahoma Cowboy Band and its travels. After his retirement from show business, Gray also became involved in civic activities. (Courtesy Vicki George.)

World War II affected the Gray family just as it touched the lives of most families in America. Otto and Florence Gray's son, Owen, served in the army during the war. Here he is seen standing in front of his parents' home in Stillwater. (Courtesy Vicki George.)

Among the photographs left behind by Otto was one of Owen's wife, Frances Reis, of Greenfield, Ohio. She and Owen were married around 1934. They were later divorced, and Owen died in 1947. However, Frances kept in touch with Owen's family for many years after that. (Courtesy Vicki George.)

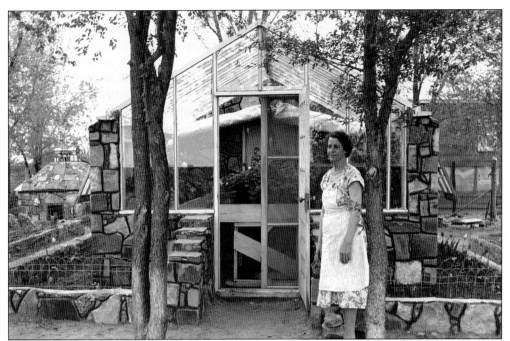

Florence is shown in the greenhouse at her home in Stillwater. There is not much information available about her activities after her years with Otto Gray and His Oklahoma Cowboys. Apparently she enjoyed growing plants, which is something she could not do during her years of touring with a cowboy band.

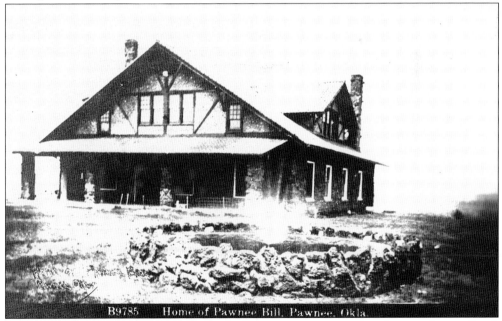

This postcard of Pawnee Bill's home near Pawnee was among the photographs in Gray's collection. The home was built on Blue Hawk Peak in 1910. The Pawnee Bill Ranch is now maintained by the Oklahoma Historical Society and is open to the public. Pawnee Bill's Wild West Show is periodically reenacted at the ranch.

In his later years, Benjamin "Whitey" Ford visited Otto Gray at his home in Stillwater. Ford, who performed with Otto Gray and His Oklahoma Cowboys, went on to success as a comedian on the Grand Ole Opry in Nashville. Known as the "Duke of Paducah," Ford played the role of a hillbilly whose signature saying was, "I'm going to the wagon. These shoes are killin' me." Both Billy McGinty and Otto Gray maintained ties to their old friends throughout their lives.

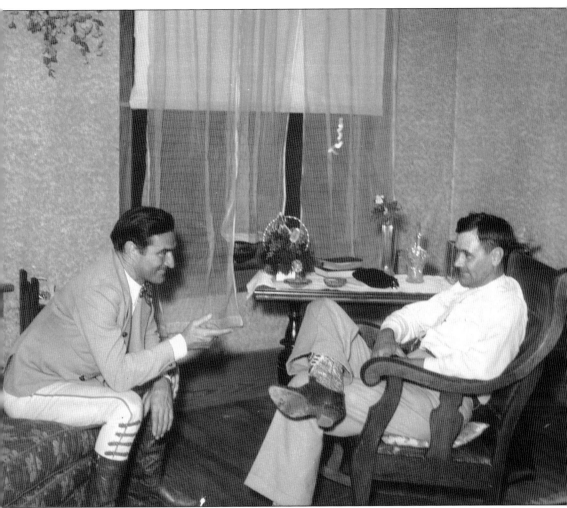

Cowboy movie star Tom Mix, on the left, visited Gray at his home in Stillwater. The two were friends in their vaudeville days, when Mix performed with a circus in the East. In addition to knowing Gray, Mix had other ties to Oklahoma, where he was once the town marshal of Dewey. He also worked as a bartender at the Bluebelle Saloon in Guthrie and became a member of the 101 Ranch Wild West Show. During the 1920s, Mix reigned over silent movies as the "King of the Cowboys."

After his retirement from show business, Otto Gray became interested in raising Palomino horses. Palominos, which are a shade of gold with a white mane and tail, make an impressive appearance. Cowboy movie and television star Roy Rogers's horse, Trigger, was a Palomino.

PALOMINO HORSE BREEDERS OF AMERICA, INC.

MINERAL WELLS, TEXAS

This certifies that OTTO GRAY

of STILLWATER, OKLAHOMA

is a member of the PALOMINO HORSE BREEDERS OF AMERICA, and in witness whereof, the said Corporation has caused this certificate to be signed by its duly authorized officers and its corporate seal to be thereto affixed.

Dated, this, the 26th day of September, A. D., 1944

Howard B Cox
PRESIDENT

This certificate attests to Gray's interest in breeding and raising Palomino horses. He had a strong interest in animal husbandry and took good care of his livestock, whether they were miniature horses, miniature cattle, or Palomino horses.

From early 1928 through 1931, the Oklahoma Cowboy Band made more than a dozen records for a variety of recording companies. Phonographs were in many homes by this time, and 78-rpm records made it possible for families to listen to music in their homes rather than going out to hear it. Today these often-scratchy records enable the listener to hear the voices of musicians long gone. This photograph shows a sampling of the records made by the Oklahoma Cowboy Band. Shown clockwise from the top are Okeh, Vocalion, Gennett, and Melotone records of music by the Oklahoma Cowboy Band. The band also made a two-reel short film produced by the Film Exchange of New York City.

David L. Payne's goal in life was to live in Oklahoma, but when the boomer leader died suddenly in 1884, he was buried in the town where he happened to be staying, Wellington, Kansas. A Payne family descendant, who is also named David L. Payne, helped the Payne County Historical Society move the boomer leader's remains from Kansas to Stillwater. A memorial service was held on a rainy April 22, 1995, to honor the man that many consider to be the "father of Oklahoma." Today the grave and memorial are on a peaceful site overlooking Boomer Lake, located on the north side of Stillwater.

Mary & Fred
Thanks for believing in
me from the start
God bless
Garth Brooks

credit: Philip Hight

GARTH BROOKS

EXCLUSIVE REPRESENTATION
Buddy Lee
ATTRACTIONS INC.
38 MUSIC SQUARE EAST · SUITE 300
NASHVILLE, TENNESSEE 37203 · 615/244-4336

Garth Brooks Fan Club Int'l
27 Music Square East, Suite 172
Nashville, TN 37203

Capitol
RECORDS

Doyle/Lewis Management
615/329-4150
615/259-2524

Garth Brooks, country music megastar, began his career in Stillwater when he was a student at Oklahoma State University. Just as Stillwater's Otto Gray was a pioneer in using western themes and attire in country music, Brooks changed country music today by integrating elements from other genres and appealing to widely diverse audiences. Brooks signed this fan club photograph for Stillwater residents Fred and Mary Causley early in his career. (Courtesy Fred and Mary Causley.)

A recent Oklahoma State University homecoming parade served as an opportunity to celebrate the heritage of Stillwater and Payne County—and to look forward as well. The parade began on South Main Street and passed the intersection of Seventh and Main Streets, where the historic Katz building is located. The building is scheduled to become the home of the Stillwater Children's Museum.

The enthusiasm of Oklahoma State University's sports fans can be intense, but university efforts in other areas engender just as much, although quieter, support. Oklahoma State University is known worldwide for its research programs that are designed to face the problems of today. (Courtesy Stillwater Convention and Visitors Bureau.)

Since the 1970s, Stillwater has been the center of what is called "red dirt music," which has become popular in Oklahoma and Texas. Music historian John Wooley describes red dirt music as a "blend of rock, country, and roots music, with a little bit of folk." That description certainly applies to the music of Stillwater's Red Dirt Rangers. Shown above are, from left to right, Red Dirt Rangers Brad Piccolo, John Cooper, and Ben Han. (Courtesy Red Dirt Rangers.)

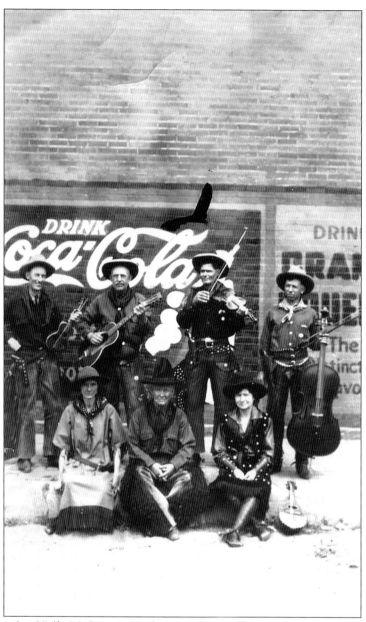

This photograph of Billy McGinty's Cowboy Band, as well as many other photographs of the band's history, may be seen in the Washington Irving Trail and Museum, southeast of Stillwater. The museum is primarily concerned with the area north of the Cimarron River in eastern Payne County. This area, rich in history, is where Washington Irving camped on October 20, 1832. A Civil War battle was fought in eastern Payne County in 1861, and a shoot-out between the Doolin-Dalton gang and U.S. marshals took place at Ingalls in 1893. One of the area's most famous residents was Billy McGinty, a legendary cowboy and Rough Rider, as well as the leader of the first cowboy band to broadcast over the radio. Otto Gray took the cowboy band on the road, where they became the first western band to perform on vaudeville, inspiring many show business imitators. In 2002, the American Association for State and Local History recognized the Washington Irving Trail and Museum for its exhibits on the history of Payne County.

BIBLIOGRAPHY

Alexander, Mabel Hovdahl. *Via Oklahoma: And Still the Music Flows*. Oklahoma City, OK: Oklahoma Heritage Association, 2004.

Allen, Gene. *Voices on the Wind: Early Radio in Oklahoma*. Oklahoma City, OK: Oklahoma Heritage Association, 1993.

Berry, Camelia Uzzell. *The Story of Berry Bros. in Indian Territory*. Cortez, CO: Mesa Verde Press, 1988.

Carney, George O., and Hugh W. Foley Jr. *Oklahoma Music Guide: Biographies, Big Hits & Annual Events*. Stillwater, OK: New Forums Press, 2003.

Chlouber, Carla. "Otto Gray and His Oklahoma Cowboys: The Country's First Commercial Western Band." *Chronicles of Oklahoma* LXXV, no. 4 (Winter 1997–1998): 356–383.

Irving, Washington. *A Tour on the Prairies, edited with an introductory essay by John Francis McDermott*. Norman: University of Oklahoma Press, 1956.

McRill, Leslie A. "Music in Oklahoma by the Billy McGinty Cowboy Band." *Chronicles of Oklahoma* XXXVIII, no. 1 (Spring 1960): 66–74.

Mitchell, Alvan. *Little Tom and Fats*. Stillwater, OK: Forum Press, 1983.

Newsom, D. Earl. *The Story of Exciting Payne County*. Stillwater, OK: New Forums Press, 1997.

Shirley, Glenn. "Daddy of the Cowboy Bands." *Oklahoma Today* (Fall 1959): 6–7, 29.

———. *Gunfight at Ingalls: Death of an Outlaw Town*. Stillwater, OK: Barbed Wire Press, 1990.

Wooley, John. *From the Blue Devils to Red Dirt: The Colors of Oklahoma Music*. Tulsa, OK: Hawk Publishing Group, 2006.